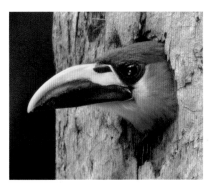

JUNGLE OF THE MAYA

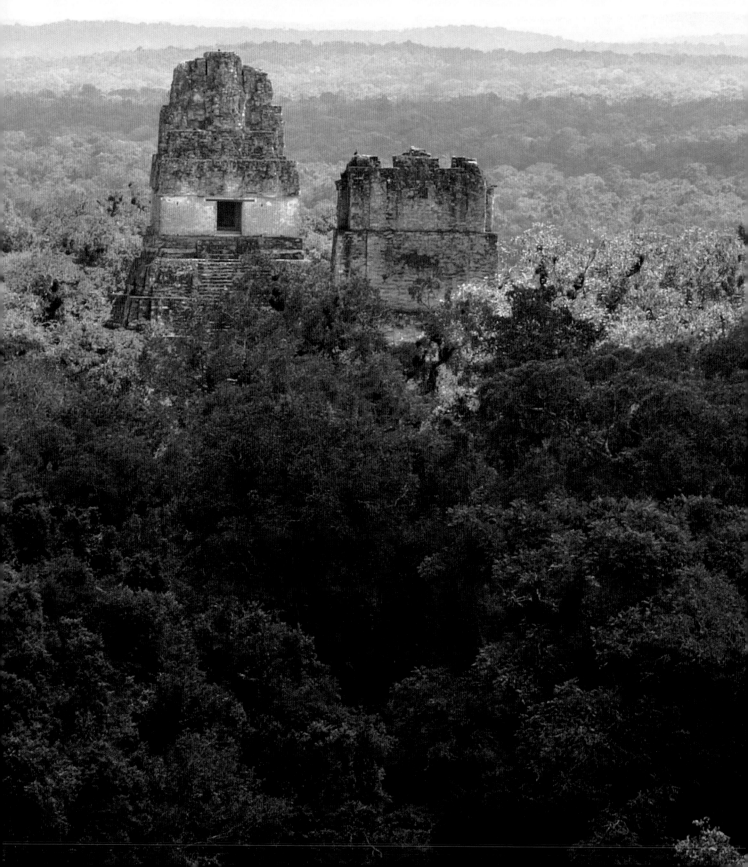

the MAYA

Photographs by
DOUGLAS GOODELL
and **JERRY BARRACK**

Text by **JIM WRIGHT**

Foreword by
ARCHIE CARR III

University of Texas Press
Austin

Page i: Emerald Toucanet. Title page: Tikal. Opposite page: Toucan.
Page vi: Full moon over Tikal.

Publication of this book was aided by the generous support of Richard C. Bartlett,
Susan Aspinall Block, and the National Endowment for the Humanities.

Designed by Ellen McKie, University of Texas Press

Requests for permission to reproduce material from this work should be
sent to:
Permissions
University of Texas Press
P.O. Box 7819
Austin, TX 78713-7819
www.utexas.edu/utpress/about/bpermission.html

⊗ The paper used in this book meets the minimum requirements of
ANSI/NISO Z39.48-1992 (R1997) (Permanence of Paper).

LIBRARY OF CONGRESS CATALOGING-IN-PUBLICATION DATA

Goodell, Douglas, 1939–
 Jungle of the Maya / photographs by Douglas Goodell and Jerry
Barrack ; text by Jim Wright ; foreword by Archie Carr III.— 1st ed.
 p. cm.
 Includes bibliographical references and index.
 ISBN-13: 978-0-292-71412-0 (cloth : alk. paper)
 ISBN-10: 0-292-71412-2 (cloth : alk. paper)
 1. Rain forest animals—Maya Forest. 2. Maya Forest. 3. Rain forest
animals—Maya Forest—Pictorial works. 4. Maya Forest—Pictorial works.
I. Barrack, Jerry. II. Wright, Jim. III. Title.
 QL228.M39G66 2006
 578.7340972—dc22
 2005034425

FOR LILLIAN

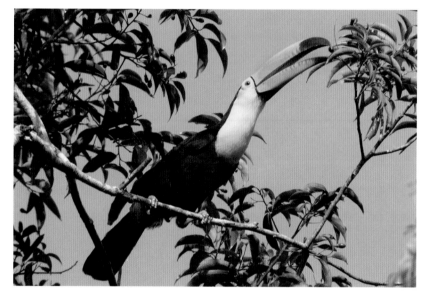

*The wild places are where
we began. When they end,
so do we.*

DAVID BROWER

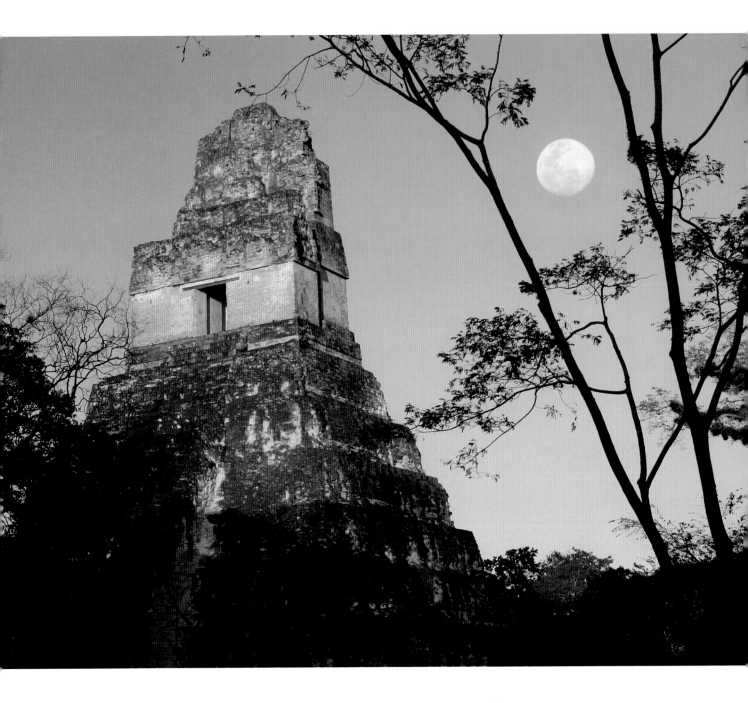

Contents

Jaguar in Maya bas-relief

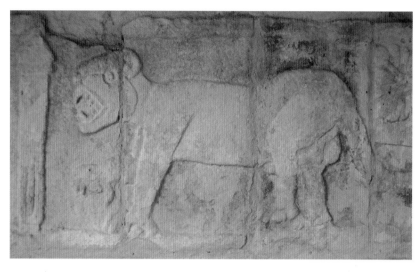

Jaguars, sacred to the ancient Maya, are among the most magnificent creatures in the jungle, and among the most endangered.

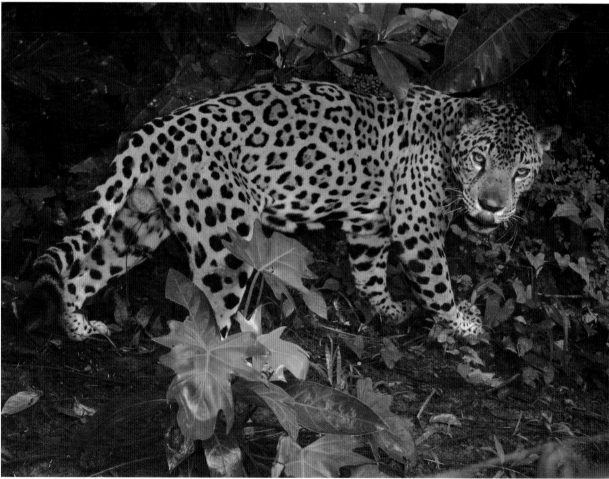

Foreword

To walk in the shadows of the temples of Tikal is to walk with ghosts. These spirits, while content to live on in the beauty and solemnity of the place, are eager to teach, to convey a message, a lesson: the story of the Selva Maya.

A noble people built these temples and, in some cases, whole magnificent cities, here at Tikal, at Copan in the south, at Chichen Itza far to the north, and innumerable sites in between. Those noble societies are gone, and as modern visitors explore the shadowed remains, they inevitably ask why and try to grasp the lesson of the Selva Maya.

The Maya knew the marvel, mystery, and splendor of nature. Images from their natural surroundings, beginning with those of the mighty jaguar, are reflected in their glyphs, pottery, sculpture, and, of course, the parables of the Maya epic tale of creation, the Popol Vuh.

Clearly, their art shows they understood color and form in nature, but what about function? Did the Maya hold to some rudimentary sense of ecology? Surely. The Maya were farmers who had to feed millions of people during the Classic Maya period. Growing crops of any sort requires a grasp of basic principles of ecology. Without that understanding, life isn't feasible.

Yet most modern observers easily gravitate to the conclusion that the Maya exceeded the carrying capacity of their lands (and waters!) and crashed as a civilization. Native species survived, and that is intriguing. The fossil record shows no evidence that the Maya were responsible for the extinction of any type of plant or animal.

Even the Maya bloodline itself persisted and flourishes today in the New World. It was the unique social order of the day that failed, and failed cataclysmically.

Today, the Selva Maya is at risk again. As modern beings, can we manage the forest better than we believe the ancient Maya did? We should. We have the archaeological record to draw from. We have modern science. And we still have inspiration whispered to us by spirits in the great plazas of Tikal and beyond.

Turn the pages, and witness.

ARCHIE CARR III, a senior conservationist with the Wildlife Conservation Society, has worked and studied in the Mesoamerican region for almost four decades. Carr views the Selva Maya as the capstone in the Mesoamerican Biological Corridor, a multination initiative that he helped create.

JUNGLE OF THE MAYA

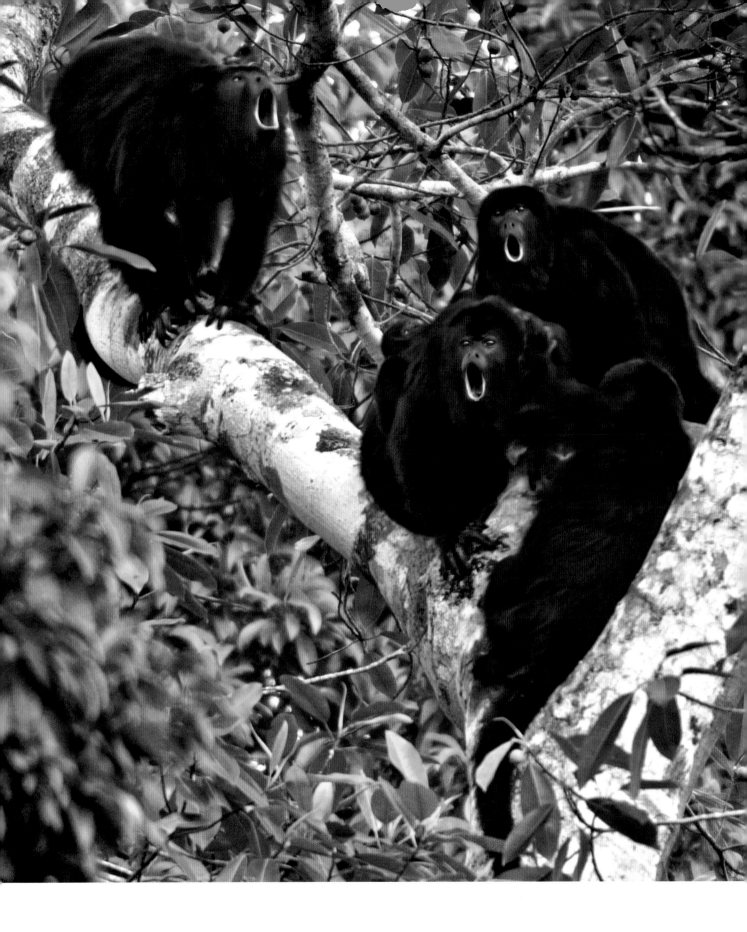

Introduction

 ungle of the Maya celebrates one of the world's most magical yet least appreciated places, the Selva Maya, an enormous tropical forest that encompasses much of Belize, Guatemala, and Mexico's Yucatan Peninsula. At nine million acres, it is the largest contiguous tropical forest north of the Amazon in the Western Hemisphere.

"Selva Maya" is Spanish for "forest of the Maya," named after the civilization that dominated this region for more than a millennium and influences it still. The region is home to thousands of remarkable plants and creatures and archaeological sites.

To capture some of that splendor, we have made repeated visits to the region for several years, in all seasons. Aided by expert local guides, we worked in some of the forest's best-protected areas, including the 140,000-acre Tikal National Park in Guatemala, the 1.3 million–acre Sian Ka'an Biosphere Reserve in Mexico, the 100,000-acre Cockscomb Basin Jaguar Refuge in southern central Belize, and a 390,000-acre parcel in northwestern Belize comprising the Programme for Belize's Rio Bravo Conservation Area as well as the privately owned Gallon Jug parcel with Chan Chich Lodge.

These swaths of forest represent the Selva Maya at its most vibrant. They harbor amazing creatures that most people get to see only in magazines or on TV, including creatures imperiled almost everywhere else they exist, from howler monkeys to jaguars.

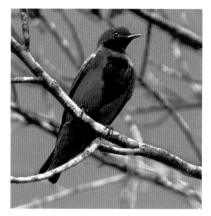

Lovely Cotinga

Opposite page:
Howler Monkeys

3

To show further examples from the Maya civilization, we also worked in Mexico's Yucatan region at Tulum, Chichen Itza, and Uxmal. Although they are not moist forest, these areas were also part of the ancient Selva Maya.

The Maya forest is crucial to the long-term well-being of the entire Western Hemisphere. Unfortunately, far too many people are ignorant of or just plain misinformed about this fact. On one Web site, some skeptics claim that nobody should worry about destroying a jungle because it's only good for mosquito-borne diseases and deadly snakes and spiders. Others insist that protecting the Selva Maya is somehow "evil" because it defies God's command to Adam to subdue the earth.

Our goal is to show why it would be a far greater evil for humankind to continue on its current path of destruction. Noah didn't build his ark solely for humans. All living creatures are in the same boat, but humans will be the ones who save or sink it.

*I*n an effort to reflect the essence of this great forest, we took more than 20,000 photographs. All but a few of the animals were photographed in the wild. The exceptions are several cats (the jaguar, puma, jaguarundi, and margay), two endangered birds (the

The extent of the Selva Maya is outlined in red. Technically, the Selva Maya constitutes only the lowland tropical forest within this area, not the higher elevation areas. In common usage, the terms "forest," "jungle," and "rainforest" are used almost interchangeably. The shaded area on the map represents the extent of the Maya culture, and important Maya sites are indicated. Modern biosphere reserves and conservation areas are shown on the map in Chapter 11. (Based on maps presented by the Mesoamerican Biological Corridor Project.)

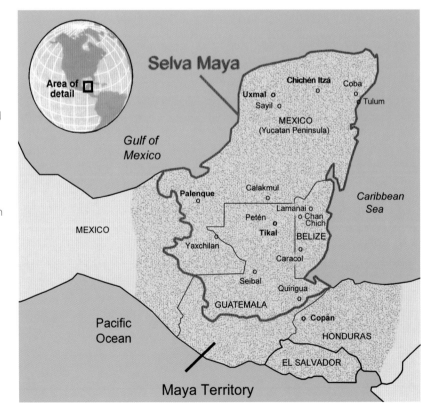

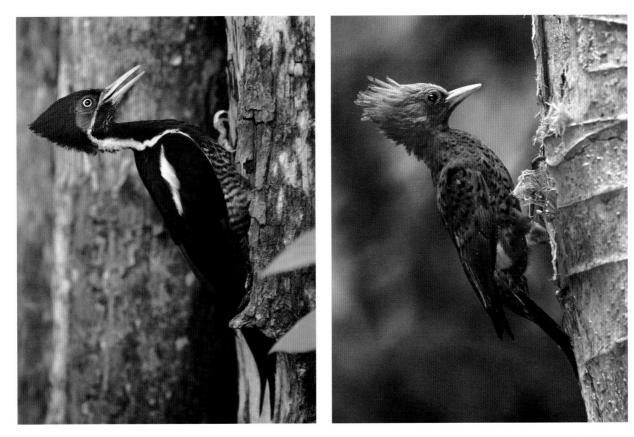

scarlet macaw and the harpy eagle), and a few butterflies. The cats are extraordinarily difficult to see in the wild, let alone photograph. The scarlet macaw and harpy eagle are extremely rare, and a couple of butterflies proved elusive as well. Only after many, many unsuccessful attempts to photograph these butterflies in the wild did we choose to use images of them in captivity so that readers might see them close up.

Finally, we wish to note that *Jungle of the Maya* is neither a guidebook to the entire region and its wondrous creatures nor a treatise on the huge challenges that threaten it. Our book touches on these elements, but it is more a celebration of the wild beauty that awaits those with eyes and mind wide open.

The Selva Maya is home to nearly two dozen woodpecker varieties, including the Chestnut-colored (above right). The Lineated Woodpecker (above left) is found in semi-open areas; the male shown here has more red on the face than the female. The Lineated is arguably Central America's largest woodpecker (along with the Pale-billed). The only species that is larger, the Imperial, has not been seen recently and is presumed extinct.

Overleaf: The main plaza at Tikal

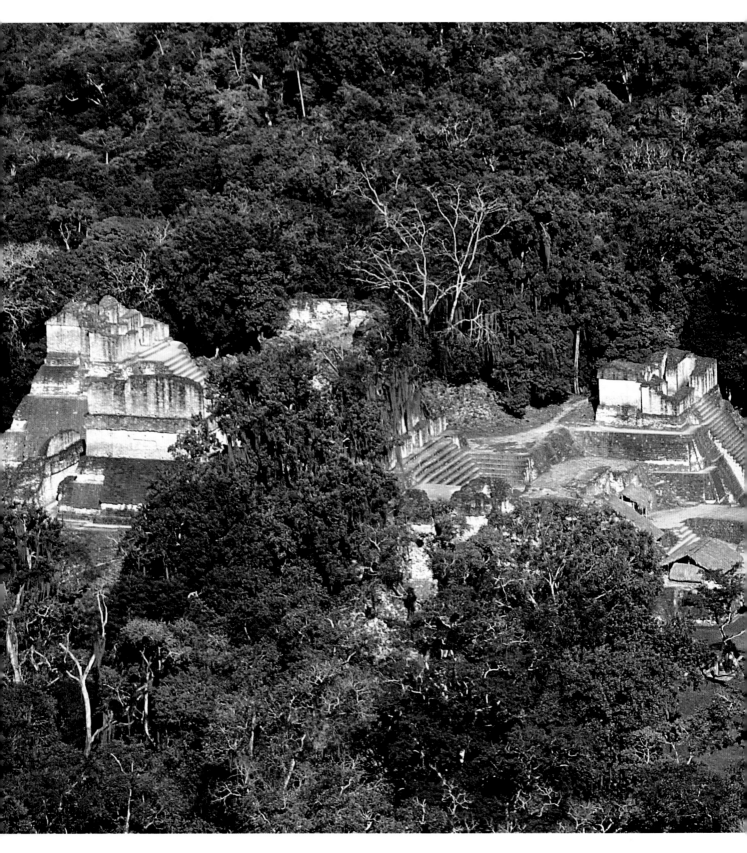

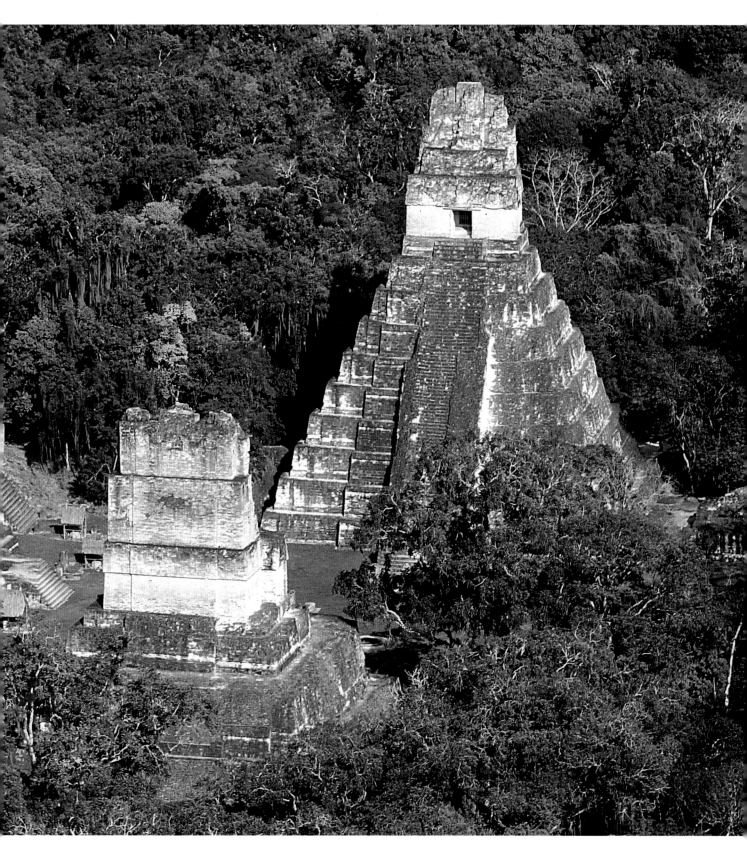

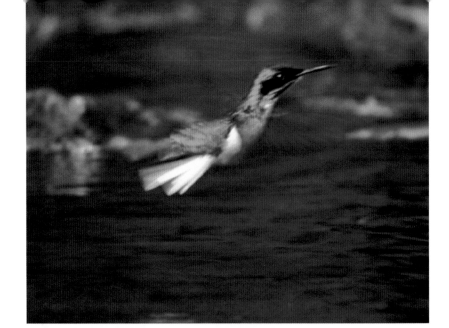

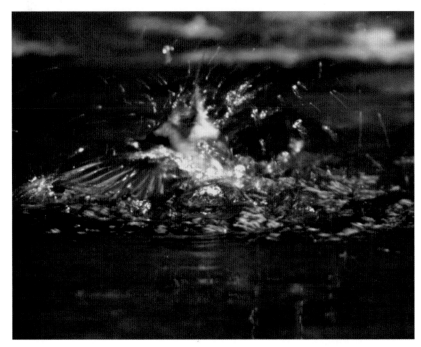

A Purple-crowned Fairy bathes in Chan Chich Creek. Only the male has the violet crown. Thanks to an unusual wing structure that enables hummingbirds to flap in a figure-eight motion, they can hover like a bee or zip forward, sideways, and even upside-down.

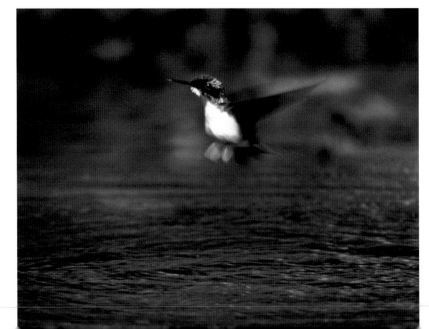

ONE

Welcome to Eden

ear a tranquil creek in the vast Central American jungle known as the Selva Maya, one of nature's small miracles materializes each morning.

From out of nowhere, a sparkling-green wisp of a bird appears. His wings flutter so rapidly (25 times a second) that they blur.

At midstream, he hovers long enough for a breath of sunshine to glisten off his lavender head. Then he plunges and makes a delicate splash—once, twice, three times. An instant later, he is gone.

In a few blinks of a human eye, a hummingbird known as the purple-crowned fairy has taken his morning bath and vanished as mysteriously as he arrived.

The only proof that he was more than an apparition is the concentric dapples on the water, and a fleeting but indelible image that has been etched on your memory.

If you step back from the banks of the softly flowing waters, a larger scene emerges. A towering canopy of trees. A tropical forest so dense you can barely see ten yards. It is a place like no other.

Gripping a nearby gumbo limbo tree is an old man lizard, all scales and tail. By the water's edge, not far from where the hummingbird fluttered, a rare agami heron stands motionless as it waits for breakfast to swim past. In the distance, a chain of spider monkeys makes its daily commute.

Some say that to visit this swath of the Selva Maya ("selva" is Spanish for "forest") is to visit another world, but that isn't quite true. To visit this place is to visit many other worlds.

At my finest moments in wild nature, such as I experience hour by hour in a tropical forest, I feel as if my whole being is on tiptoe.

NORMAN MYERS,
THE PRIMARY SOURCE (1984)

9

"Old man lizard" is a catch-all term in Central America for several species of lizards, including Hernandez's Helmeted Basilisk, pictured here. The tail continues another body length. Unlike most lizards, which rely on speed and agility for survival, this old man uses the ability to remain motionless.

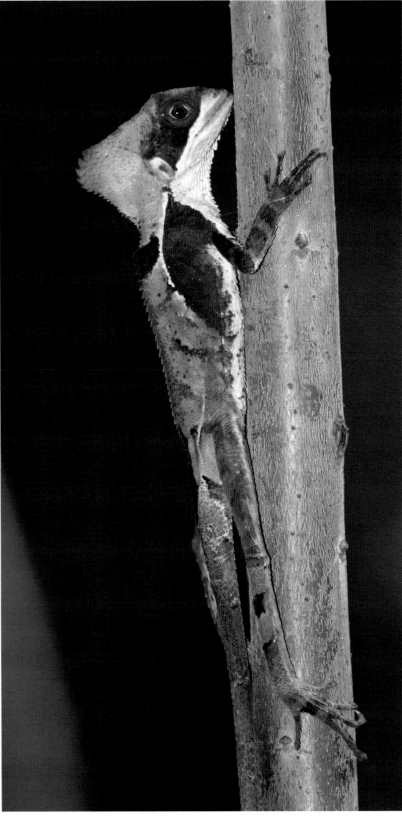

Black Orchid,
national flower of Belize

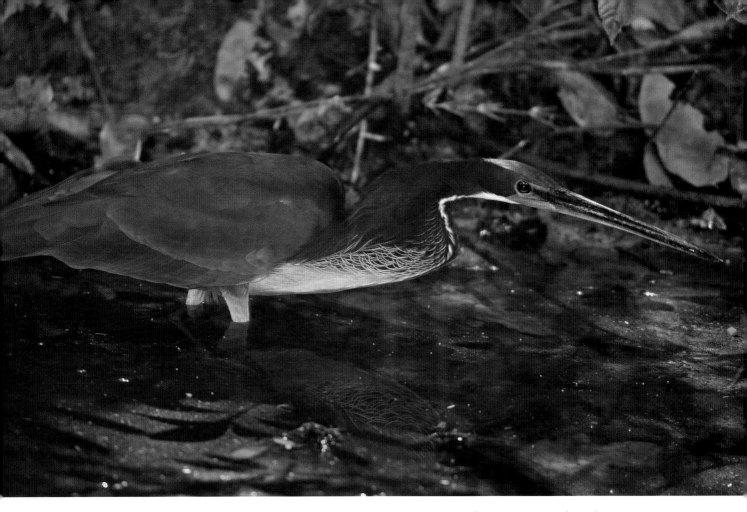

This is the world of the tropical jungle, a lush paradise that contains enough exotic species, from red-eyed treefrogs and morpho butterflies to crocodiles and boarlike peccaries, to fill a dozen arks.

This is the world of the magnificent jaguar, the largest cat in the Western Hemisphere. It is also the most elusive, and the most endangered. Here, in the heart of the Maya jungle, it can roam free without fear of big-game poachers and other human predators.

This is the world of winged splendor, of ocellated turkeys, motmots, toucans, trogons, and hawk-eagles. The jungle is a birder's paradise, home to more than 500 species and destination for an estimated one billion birds that migrate from the United States and Canada each autumn.

This is the world of the remarkable Maya, one of the great ancient civilizations. More than a millennium ago, much of the Maya empire suddenly collapsed. Solving this mystery, with many of the clues still buried under centuries of overgrowth, could help the region thrive.

This tropical forest once encompassed tens of millions of acres in Guatemala, Mexico, and Belize. Human encroachment has whittled it to a fraction of that. To save and protect what remains, the

The Agami Heron is shy and uncommon. Also known as the Chestnut-bellied Heron, it hunts in shaded pools and streams, using its long slender bill to spear fish. It is one of the world's most beautiful herons, and one of the most rarely seen.

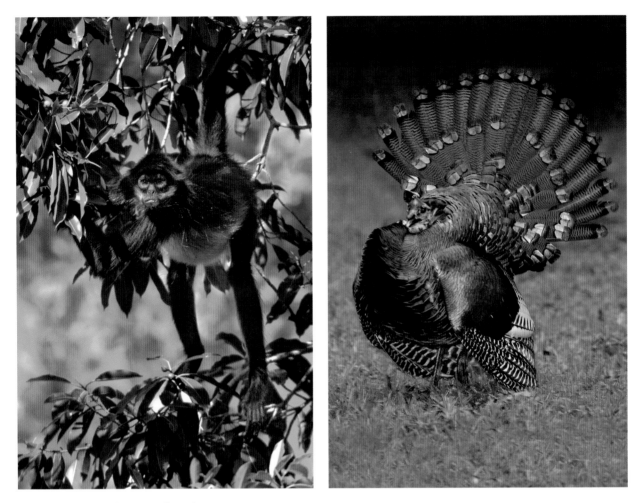

Spider Monkeys get their name from their long slender arms, legs, and prehensile tails. They live and travel in the forest's upper canopy. They range throughout Central America but could face extinction as a result of the loss of habitat.

This male Ocellated Turkey is in a mating display. Unique to the Selva Maya region, it has been heavily hunted and is now seen mostly in protected areas, such as Rio Bravo and Chan Chich in Belize and Tikal in Guatemala.

three nations have created biosphere reserves, national parks, and other conservation areas. In addition, natural corridors have been created, extending across borders to connect the protected areas and provide migratory routes to ensure the genetic diversity needed for several endangered species to survive. The reserves promote sustainable development and environmentally aware ecotourism. Archaeologists are able to investigate the hundreds of ancient Maya sites, and scientists and naturalists can study the marvelous plants and creatures.

But as with so many of the world's wild places, nature and an ever-expanding human population are a poor fit. Instead of coexisting, they collide, and too often the power saws and machetes win.

Throughout the Selva Maya are several well-protected pockets, latter-day Edens that show how vibrant the jungle can be when humans give it breathing room. These Edens tell a larger story as well—a story of how the great Maya forest once was, and what it can aspire to become once more.

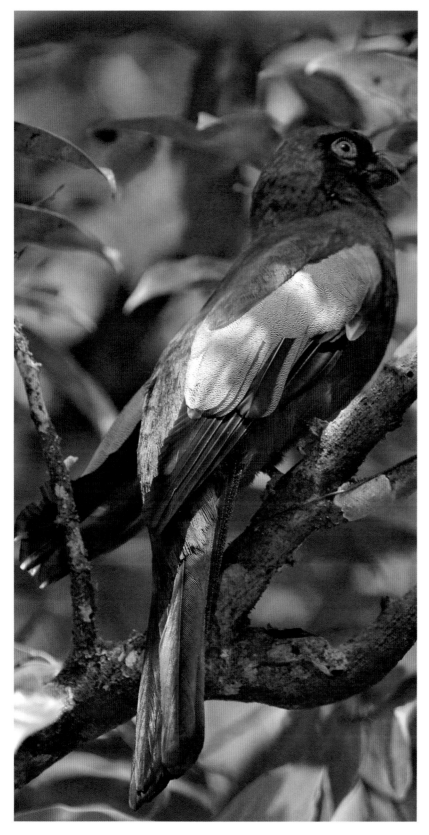

The Slaty-tailed Trogon, the largest trogon in the region, is a perfect bird to watch, not only because of its plumage but also because it tends to stay still when perched while humans are present. It nests inside termite nests on the sides of trees.

The Blue-crowned Motmot is the largest of the motmot family. Its low-voiced *hoot-hoot* resonates throughout the forest. The webbing of the two long tail feathers wears off to form the distinctive end paddles. The birds nest in holes excavated in earthen banks. They are often seen near ancient Maya sites.

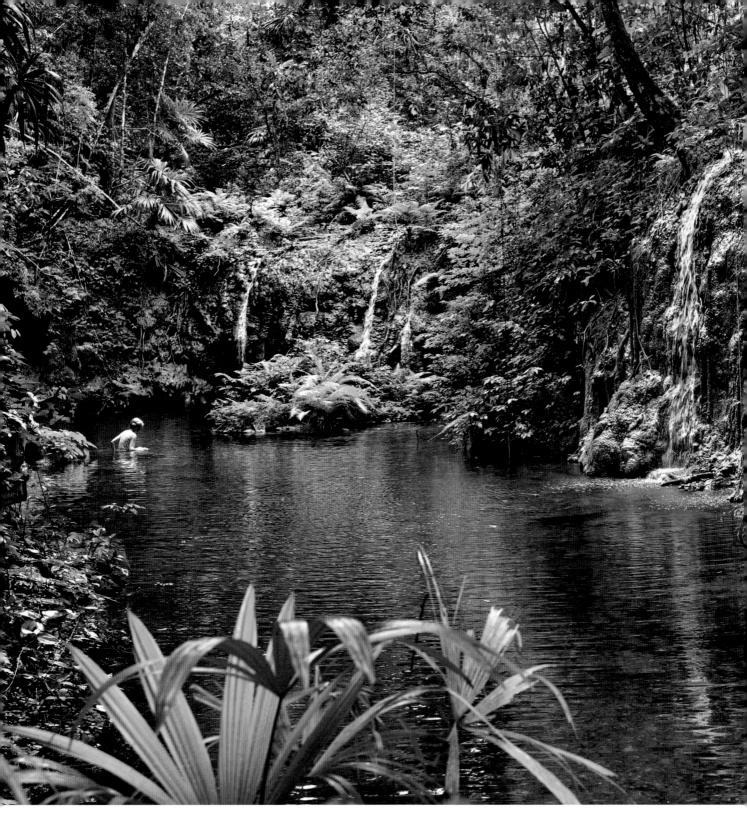

Hidden deep in the jungle in northwestern Belize is the Serena Maya, where water from a stream cascades over surrounding cliffs. The crystal-clear water in the pool below reveals the many colors of the bottom rocks and plant growth, as well as many tropical fish.

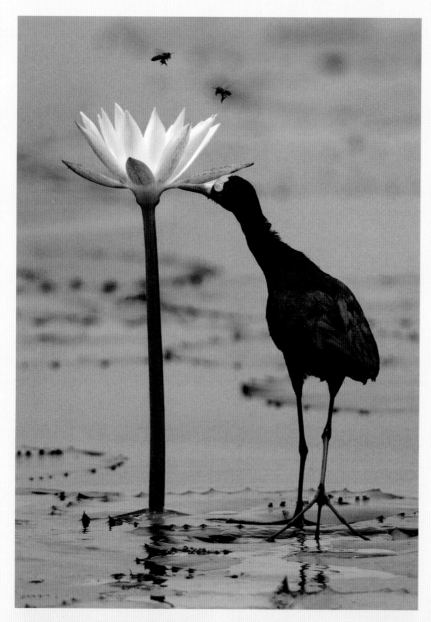

Flowers . . . are a proud assertion that a ray of beauty outvalues all the utilities of the world.

RALPH WALDO EMERSON, "GIFTS"

The Northern Jacana is a waterbird that goes from lily pad to lily pad as it looks for food. The extraordinary shape of its feet distributes the Jacana's weight across the lily pad.

Hibiscuses (below left) and Heliconias (below center and right) are abundant in the Selva Maya. Heliconia flowers are often called lobster claws or parrot beaks, but their shape is adapted to the bills of the hummingbirds that pollinate them.

Collared Aracari
Opposite page: Red-lored Parrot

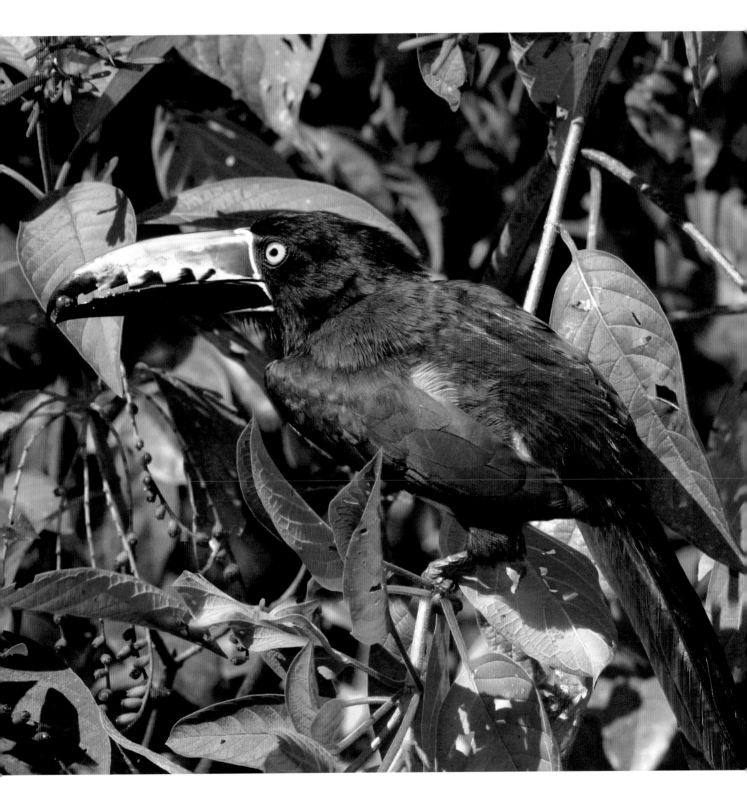

TWO

At the Jungle's Edge

arkness still cloaks the jungle sky when the noises start: the primeval roars of distant howler monkeys, the cascading gobbles of large birds known as Montezuma oropendolas, the exultations of the aptly named melodious blackbirds. Soon, in air laced with fresh allspice, the early-morning sun illuminates the aerial displays of the collared aracaris and parrots and hummingbirds as they fly above the nearby tropical forest. Welcome to the jungle's edge, a place where human boundaries end and the natural world takes over.

This is the place to first view the jungle, to see how tall the canopy grows, how dense the snarl of vines gets, how impenetrable it all seems. Though many purists insist that the word "jungle" (from the Hindi *jingli*, or "tangle") refers only to the first few yards of dense underbrush that forms a natural barrier between the human world and the forest, common usage and common sense argue for the wider meaning. It's simpler to use the term "jungle" when referring to a tropical forest or rainforest, especially when most people think that's what a jungle is. As for calling it a "Neotropical" forest, that simply means it is in the tropics of Central and South America, south of the Central Plateau of Mexico.

The best time of day to witness the jungle is typically in the early morning, the busiest time for many birds and animals. The advantage of viewing the jungle's edge from a lodge veranda or the porch of a cabana in the hour after dawn is that it's comfortable, lower on bugs, and cooler. Navigating the jungle can be hot and

Everything unfolds in a land of natural dreamscapes.

MIGUEL ANGEL ASTURIAS,
THE MIRROR OF LIDA SAL
(1967)

The multicolored Montezuma Oropendolas live in colonies near the forest's edge from January into the summer, then they move deep into the jungle. Their woven nests resemble hanging baskets much like oriole nests. Their call is unmistakable, an amazing, cascading gargle.

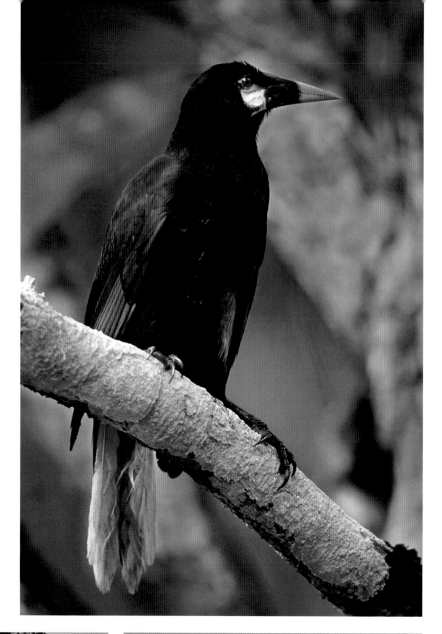

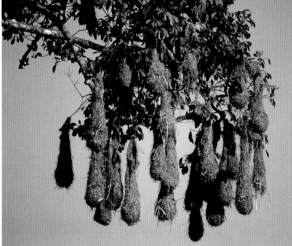

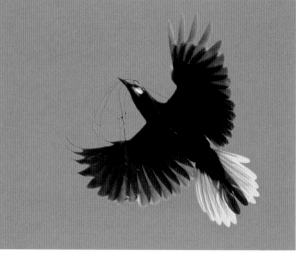

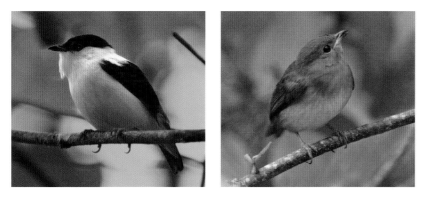

The White-collared Manakin (left), with his bright yellow plumage, spends up to four-fifths of his day courting female Manakins (center). They feed on fruit and insects. The male Red-capped Manakin (right) is known for his firecracker-like call, yellow pantaloons, and elaborate courting dance.

tiring work. Better to stay in one place early on and let nature come to you: lizards, herons, manakins, butterflies, and hummingbirds.

As David Allen Sibley points out in *Birding Basics,* his book on bird identification, "Bird activity is often concentrated along the edges—the edge of a lawn, pond, or woods tends to be more productive than the center—and you should search initially along these borders."

The jungle's edge offers a surprising array of creatures that seem to prefer human company, or at least like to be near human activity. What's more, to be outside a jungle, looking in, affords a much better view of the sky—and the raptors and toucans and parrots and other frequent fliers that soar or zip past.

One of the best ways to see wildlife is to find a place that creatures like to visit or live, and then just stay put. The lush flowers and fruits growing around a jungle lodge attract birds galore. In the dry season, any sort of pond or fountain will bring even more. Because several lodges are in protected areas and well guarded against poachers, relatively rare creatures like howler and spider monkeys and ocellated turkeys are often on view not far from your doorstep.

Perhaps the best way to view the jungle's edge is from many visitors' first vantage point, from above, from an airplane. Although a hawk's-eye view scarcely gives a hint of the marvelous plants and creatures that live below, it does provide a sense of the jungle's vastness, its contours, its majesty. If you're lucky, you'll get an aerial view of Maya ruins and a sense of that civilization's power and achievement.

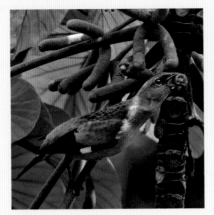 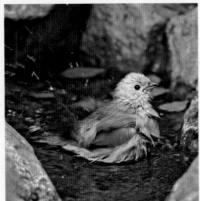 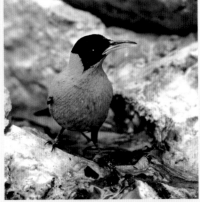

Yellow-winged Tanager
Blue-gray Tanager
Green Honeycreeper (male)

Olive-backed Euphonia (male)
Yellow-bellied Elaenia

White-collared Seedeater (male)
Northern Royal-flycatcher

 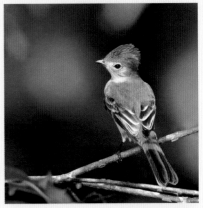

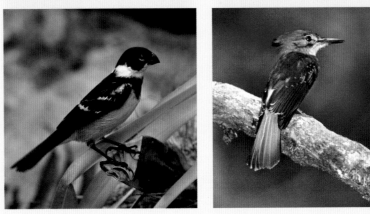

You, bird, you will live in the trees and you will fly through the air, reaching the region of the clouds, you will touch the transparency of the sky, and will not be afraid of falling.

FROM THE MAYA CREATION MYTH, POPOL VUH, TRANSLATED BY SUZANNE D. FISHER

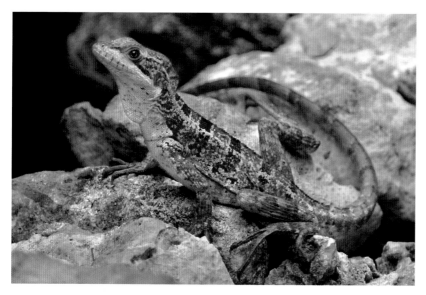

Among the lizards of the Selva Maya, the Striped Basilisk is the most celebrated (top, female; center, male). Also known as the Jesus Christ Lizard, it stands on its hind legs and runs when startled. Thanks to its speed and weblike feet, it can walk on water, a handy way to elude predators. The much smaller and more slender Brown Anole (bottom) is more shy and is likely to remain in trees.

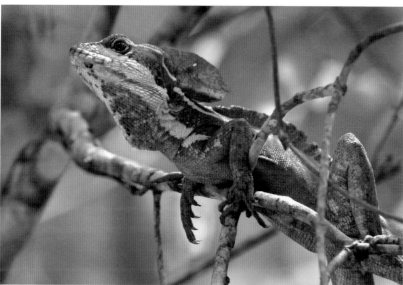

Ornate Hawk-Eagle

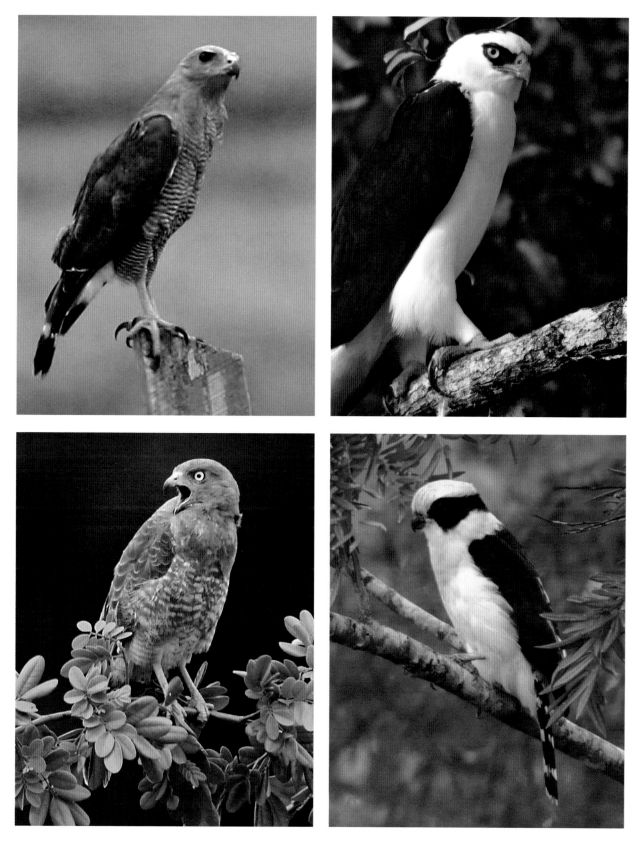

Gray Hawk (top), Roadside Hawk (bottom)　　　　Black-and-white Hawk-Eagle (top), Laughing Falcon (bottom)

The two types of deer in the region are the Whitetail (top) and the typically nocturnal Red Brocket (bottom). Whitetails, with their large antlers, prefer open habitats near the edge of the forest. In the jungle, the antlers tend to get caught in vines and brush.

Opposite page: The mammals of the Selva Maya include the raccoonlike Coati (bottom left), boarlike Peccaries (bottom center), and the weasel-like Tayra (bottom right), a fierce carnivore. The Gray Fox (top) likes to hunt along the jungle's edge.

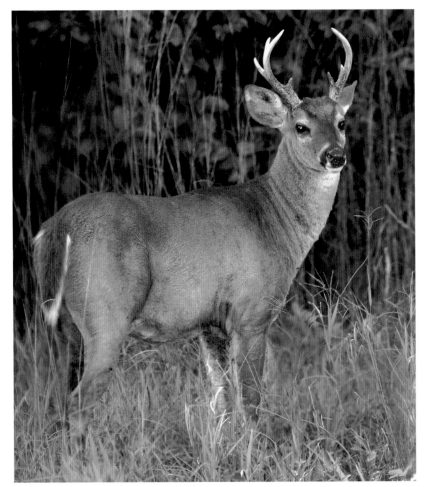

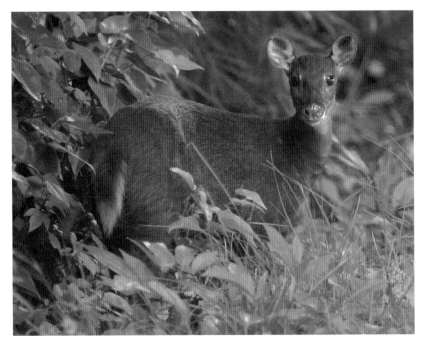

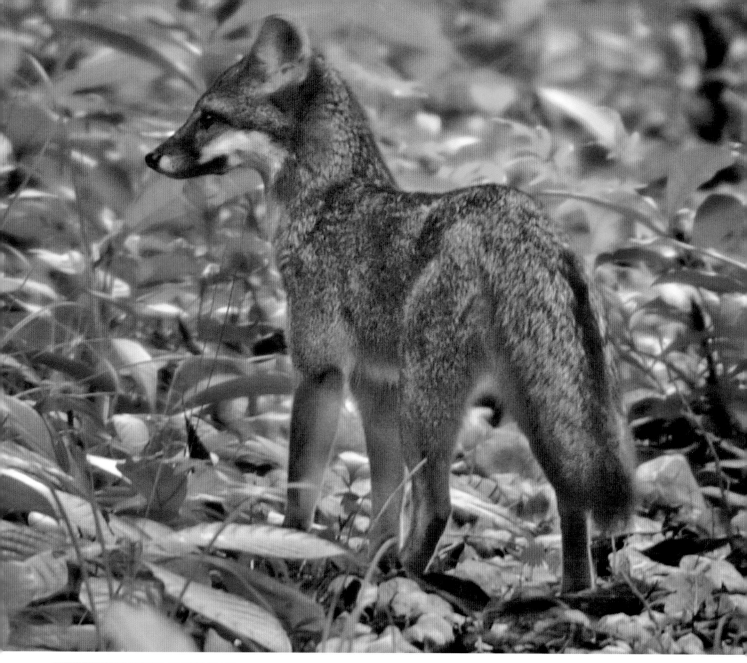

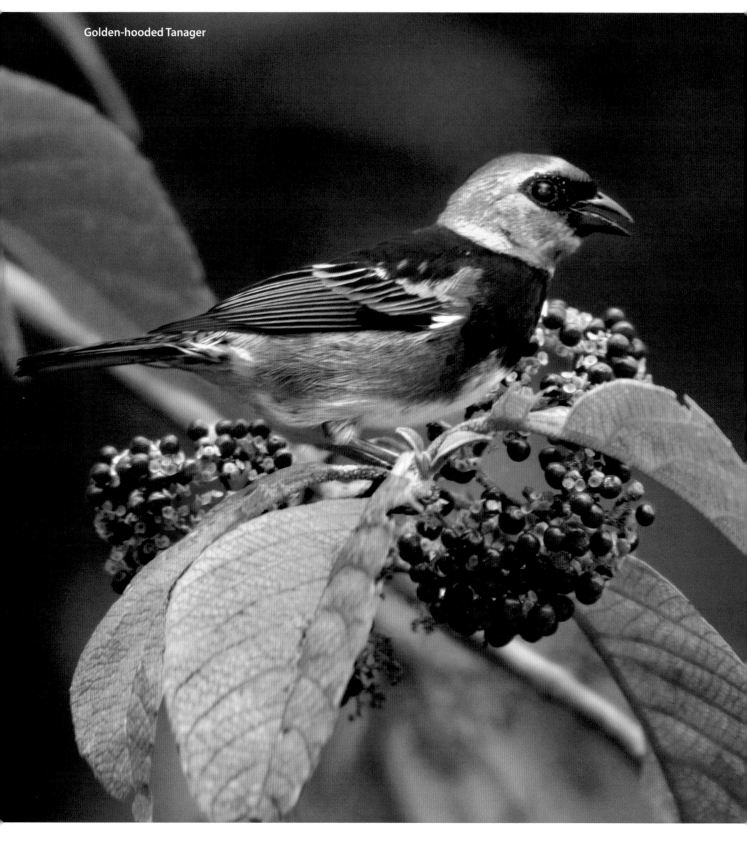

Golden-hooded Tanager

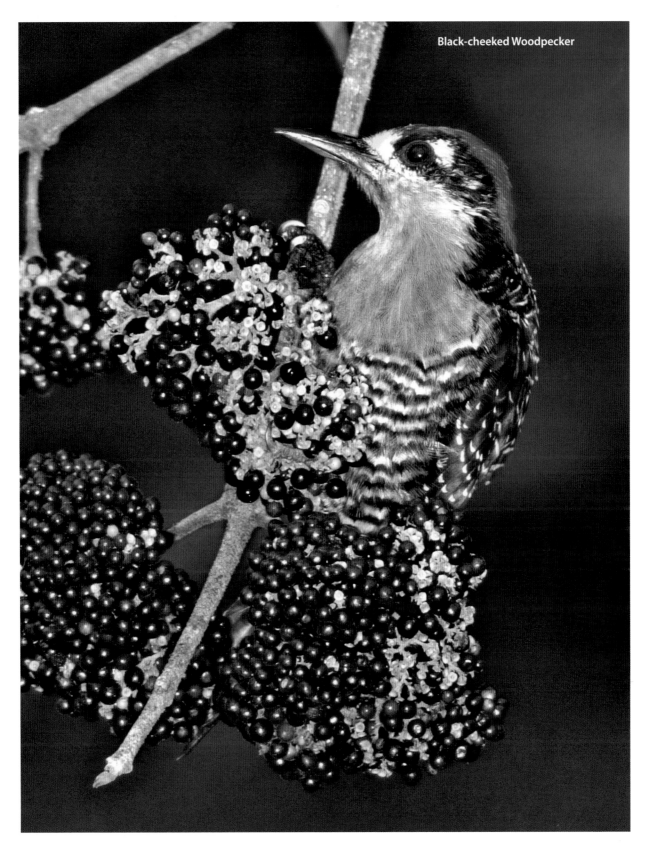
Black-cheeked Woodpecker

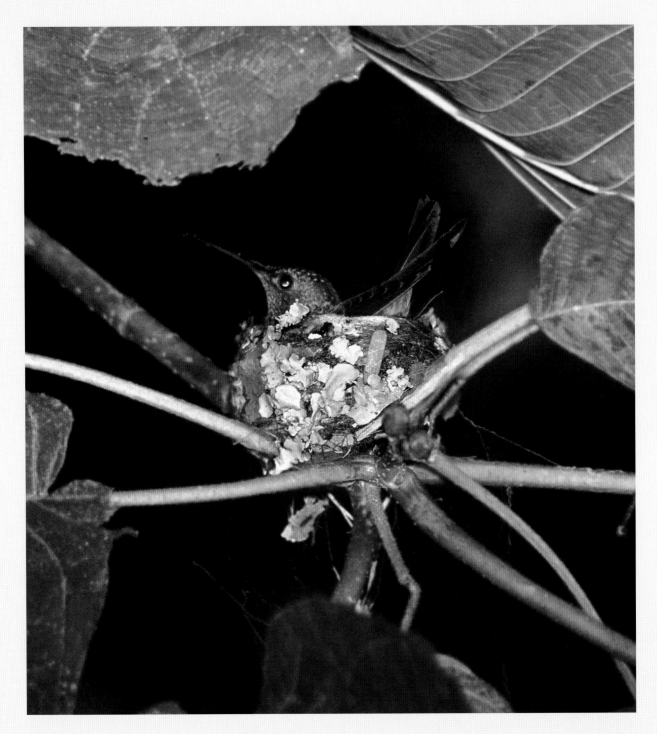

It is strange to come upon his tiny nest, in some gray and tangled swamp, with this brilliant atom perched near it, upon some mossy twig; it is like visiting Cinderella among her ashes.

T. W. HIGGINSON, *THE LIFE OF BIRDS*

*H*ummingbirds and Butterflies

othing epitomizes the Maya jungle quite like hummingbirds and butterflies, so fragile in their beauty yet so resilient. Spanish explorers called hummingbirds *joyas voladores,* or flying jewels. Butterflies are more delicate, nature's stained-glass miniatures. Both are seen as bursts of color near the jungle's edge: the butterfly flitting about, the hummingbird zooming from bloom to bloom.

Which creature is more precious depends on your point of view. Varieties of butterflies abound, with more than 17,000 species worldwide and more than 800 in Belize alone, but as is the case with many tropical forest organisms, the populations of many species in the Selva Maya are extremely low. Experts have seen some species only once in their years of fieldwork.

Hummingbirds, in contrast, are limited to the Western Hemisphere. The Maya jungle is home to roughly two dozen species, which can be frequent fliers near heliconias and other nectar-bearing red flowers. Think of it this way: In most of the industrialized world you might see a hundred airplanes a day, but you'd be lucky to see even one hummingbird. In the Selva Maya, you might see a hundred hummingbirds in a day, and just one airplane. For those who visit this region to escape that other world, this represents progress.

Just one glimpse of an airborne hummingbird will give you an inkling of what biological marvels they are. As light as a penny and often measuring under four inches from bill to tail, hummers are the world's smallest birds and some of its greatest athletes. Consider: The maximum heart rate for an adult human is roughly 160 to 200

The first sight of a living hummingbird, so unlike in its beauty all other beautiful things, comes like a revelation to the mind.

W. H. HUDSON,
A NATURALIST IN LA PLATA
(1895)

beats a minute. A hummingbird's heart routinely beats six times that fast. A world-class sprinter takes 5 strides a second in a hundred-meter dash. Hummingbirds routinely flap their wings 25 times a second, for miles at a time. They can reach speeds approaching 60 miles an hour, yet stop on a blossom.

Hummers are acrobats. Because their body structure enables them to flap their wings in a figure-eight motion, hummingbirds can hover like bees in front of a flower or zip forward, backward, sideways, and even upside-down. Their only Achilles heels are their feet, which are so small and weak that hummingbirds can't walk. To turn around or travel just an inch, they must fly.

Butterflies, at roughly a third of a hummingbird's weight, are no less exceptional in their own ways. Foremost is how they morph, from larva to caterpillar to pupa to butterfly. Because butterflies are so much more beautiful than larvae, caterpillars, or pupae (and so much easier to see) they are the crowd-pleasers. As the comedian George Carlin once remarked, "Caterpillars do all the work, and butterflies get all the publicity."

Butterflies seem so serene as they flutter along, as though they live in a world where time does not matter. A butterfly's flight, however, is deceptive. Just ask anyone who has tried to snare one with a net in the jungle.

The two major types of curved-billed hummingbirds are the Little Hermit or Stripe-throated Hermit (left) and the Long-tailed Hermit or Long-billed Hermit (right); the one pictured here is rain-soaked. Hermits have long curved bills and gravitate toward nectar-rich long curved flowers. The Little Hermit shown here seems to be stealing nectar from a flower by piercing a hole in the base without pollinating it. The Long-tailed Hermit prefers the Heliconia flower, for which its bill is perfectly designed.

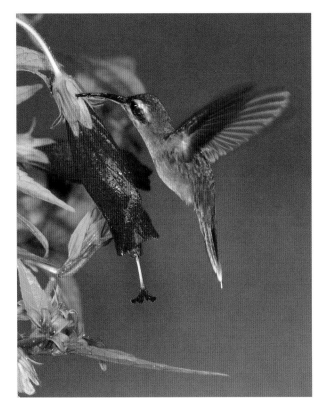

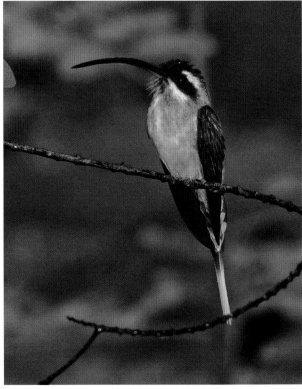

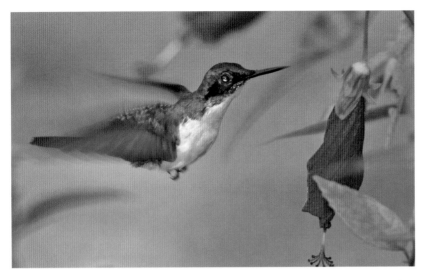

Hummingbirds are major pollinators, with short-billed hummers gravitating to short, straight flowers. On this page are (top to bottom) the Purple-crowned Fairy, the White-bellied Emerald, and the Rufous-tailed.

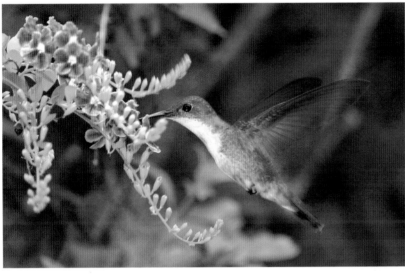

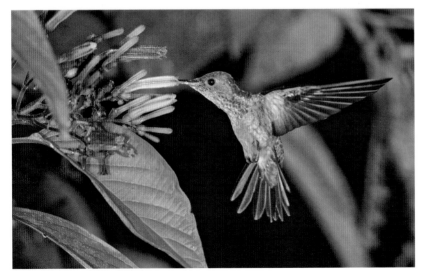

The Tiger-stripe Butterfly is one of several that have long, teardrop wings with distinctive stripes (genus *Heliconius*). The Tiger-stripe has a bad taste to many predators, a good defense mechanism. Its general color patterns are mimicked by several other butterflies.

Spotting hummingbirds in the Maya forest is relatively simple. Start with a heliconia, hibiscus, or other red bloom near the jungle's edge, then wait a while. Once you see a hummingbird at a flower, you'll likely see it again. They often return to the same blooms. Just after dawn and before dusk, when hummingbirds are either stocking up for the night ahead or awakening on an empty stomach, are often peak times.

Seeing butterflies is a greater challenge. The dry season, from February to June, is the lean season. The rest of the year, butterflies are typically seen from mid-morning to dusk. One of the benefits of watching butterflies instead of birds is that you can sleep in and still catch their prime time, nine to eleven in the morning.

One way to see butterflies is to take advantage of their need for liquids. They like wet spots on a road or path, and they like overripe fruit. Leaving a rotting banana out early in the day will increase the odds of seeing a butterfly later on.

Three of the smaller butterflies are (top left to bottom) the Long-tailed Skipper, Theona Checkerspot, and Gaudealis Patch.

The edge of a jungle is a good place to watch butterflies and hummingbirds because they both need more than one ecosystem to survive. Both feed on flower nectar in clearings, but hummingbirds build their nests inside the forest and butterflies lay their eggs there.

Aside from living on the edge, the one thing that butterflies and hummingbirds have in common is that the greatest threat to them is deforestation. "People think that butterfly collecting is the biggest threat," says Jan Meerman, an expert on biodiversity and author of the first butterfly checklist to Belize, "but what affects population the most is habitat loss. As far as we know, the populations in the Selva Maya are safe, but we're still learning so much."

Florida White
Crimson-patched Longwing

White-angled Sulphur
Dual-spotted Swallowtail

Banded Peacock
Zebra

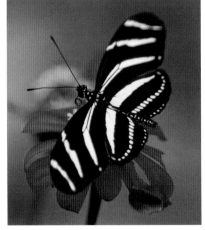

The Orion Cecropian is a large butterfly that ranges from Mexico to northern South America.

The ancient people of Mexico believed that warriors who died gloriously in battle were transformed into butterflies.

VICTORIA SCHLESINGER,
*ANIMALS AND PLANTS OF
THE ANCIENT MAYA*

The Gray Cracker (left) and Blomfild's Beauty (right) are both specific to Central America. In flight the Cracker makes an unusual cracking sound that can be heard up to five feet away. The Beauty is boldly patterned, whereas the Cracker is very subtle, but both are well camouflaged on many trees.

Spider Monkey

Spider Monkeys and Howlers

he billowing roar of the Mexican black howler monkey is the signature sound of the Maya jungle. In fact, the region is the one place on Earth where this distinctive deafening primal sound can be heard in the wild.

Howlers love to roar. They roar in the early morning, in the late afternoon, and at night. They roar before heavy rains. They roar to warn other troops to stay away from their turf. Males roar at other males. Females roar at females, and sometimes they all roar together in a mighty chorus. Of all the times they roar, they particularly seem to enjoy a deafening serenade just before dawn, nature's most jarring wake-up call.

Along with their slightly smaller cousins, the spider monkeys, the howlers are the star attractions of the jungle canopy in the Selva Maya's best-protected areas: Tikal, Cockscomb Basin, Gallon Jug/ Rio Bravo, and the Community Baboon Sanctuary in central Belize ("baboon" being another name for the howler in these parts).

Few places remain where spider monkeys and howlers can thrive. The two monkeys aren't seen in many places, especially near human settlements, because poachers kill them for meat. They need plenty of uninterrupted habitat, and the forest is slowly being fragmented.

It's no wonder, then, that the Mexican black howlers are a threatened species, and spider monkeys are on the endangered list. The populations of both species have declined by an estimated 20 percent in the past decade.

Once you have lived under the sound of the howler's roar, the echoes of the slumbering, silent jungle will have entered your soul.

IVAN SANDERSON,
LIVING TREASURE (1945)

Howler Monkey

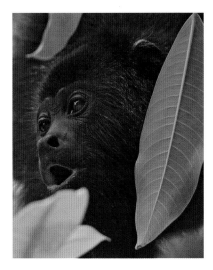

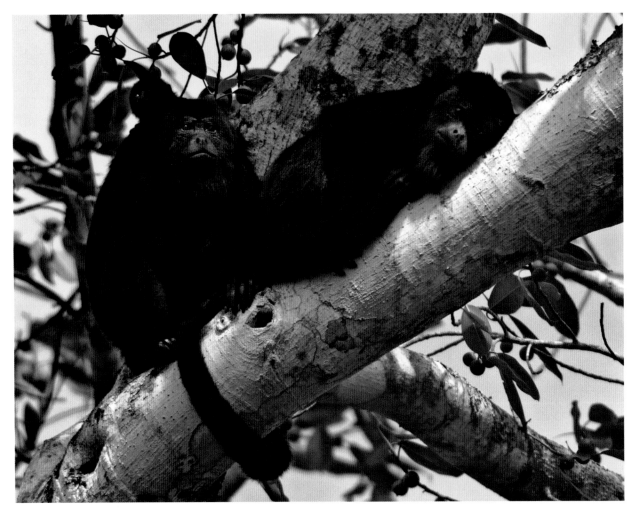

Howler Monkeys like to live up to their name. Although the male in the troop typically produces most of the deafening roars (right), females are known to join in on occasion. The Howlers tend to sound off most just before dawn and dusk but can roar at other times to mark their territory or ward off other troops. These endangered monkeys live in the forest canopy, like the family group above, with a baby. For all the racket they make, they eat fruits and leaves and pose no real threat to humans.

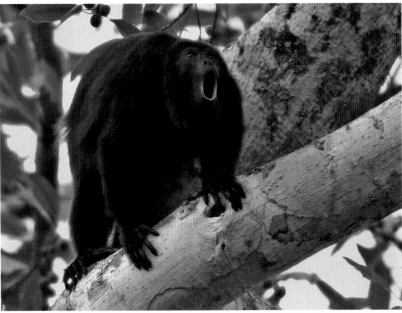

A female Spider Monkey moves through the canopy with her young on her back.

The two species are easy to tell apart in the Maya jungle. The slightly larger howlers have darker fur and move slowly across the canopy. The spider monkeys have lighter faces and chest hair, and they are far more acrobatic. They use their long slender limbs and their prehensile tails to swing from branch to branch, and they leap across small gaps in the canopy to go places.

The howlers live in troops ranging in size from three to ten, with one adult male. Each troop lives in its own section of the forest canopy (a dozen or so acres) and rarely descends to the ground. The male, at roughly sixteen pounds, is slightly larger and dominant.

As for that ferocious roar, howler monkeys have elaborate throat structures that amplify their vocal sounds to the point that males can be heard from as far as a mile away. The Maya creation myth, the Popol Vuh, has a simpler explanation. The first howlers were actually the jealous older brothers of two hero twins. The jealous brothers were banished to the canopy and turned into monkeys. They and their descendants have been howling in protest ever since.

The howlers travel in troops, but the spider monkeys have a looser social organization called a community, with as many as thirty monkeys. During the day, the spiders break off into groups of three or four to forage in different parts of the canopy, so they avoid confrontations over sparse ripe fruit. In the early evening, they congregate again. Where male howlers tend to keep their distance, male spider monkeys often travel together. Even though the spiders can't compete with the howlers' roar, they do communicate, with males often calling to others when they find ripe fruit.

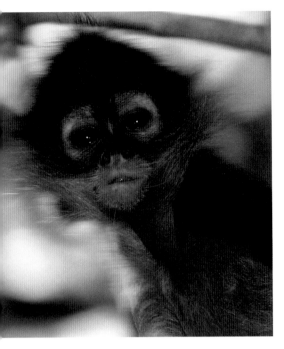

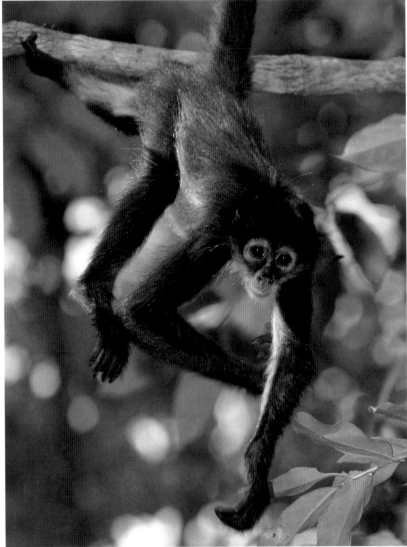

Spider Monkeys are skinnier than Howlers. Like their heavier cousins, Spider Monkeys have prehensile tails that support their weight and enable them to move through the forest more easily. Their sounds include a shriek and a bark but no roars.

Like most other primates, including humans, the howlers and spider monkeys use their hands to eat and their facial expressions to show emotion. Adult females typically give birth to just one off-spring per pregnancy, and they nurse their young.

Howlers and spider monkeys are key strands in the jungle's web of life. As the monkeys forage about the canopy, the seeds of many plant species, particularly the strangler fig and the large canopy trees, go through their digestive tracts or stick to their fur. The seeds disperse up to half a mile away. In their quest to survive, they help the jungle survive as well.

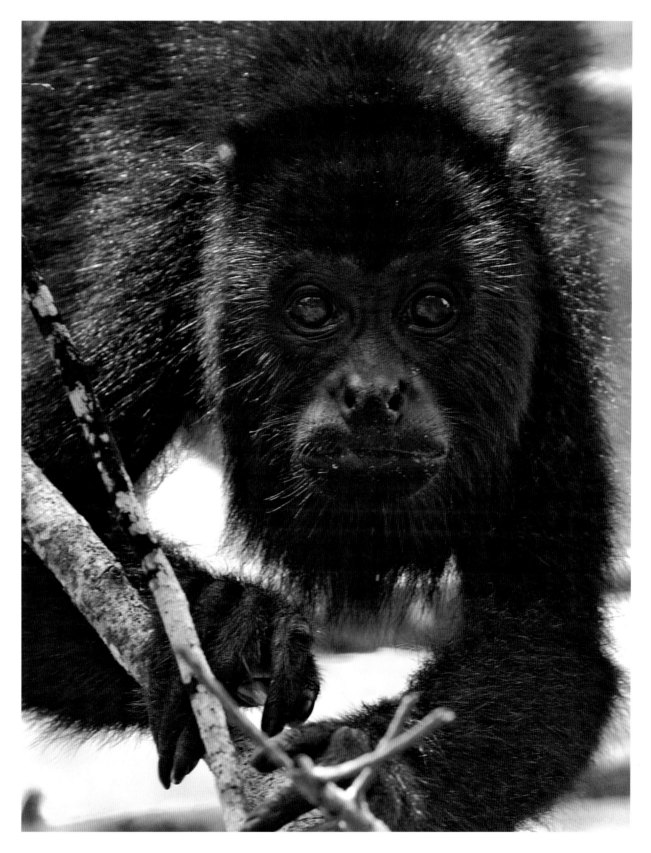

Sapoteo stump with new growth

In the Jungle

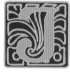 n the Selva Maya, the jungle always beckons: the thunderous growl of a howler monkey, a flash of cerulean from a blue-crowned motmot, the prospects of chancing upon an ocelot or a tayra. Somewhere in that lush and seemingly endless thicket, amazing plants and creatures and mysteries await. Absorb the jungle with all your senses and you will begin to comprehend how vast is its splendor.

A footstep or two on the jungle trail and the understory quickly grows thick and damp. The path is several feet wide and occasionally rocky, with plenty of tree roots and thick vines called lianas, reminding you to take your time.

As you travel down the trail, you get a better sense of the jungle's never-ending cycle of birth, growth, death, and rejuvenation. The signs are everywhere. A smattering of feathers on the trail is all that remains of a gray-headed dove—breakfast for a raptor. Two green saplings emerge from the stump of a sapoteo that has fallen under the machete's blade. A bullet tree grows from a fallen trunk, a reminder that although this jungle is vibrant, in some ways it hangs by threads.

Nearby but almost out of sight stands the vague silhouette of an ancient Maya temple. Time and nature have so overwhelmed the man-made mound that instead of being part of the landscape, it has become part of the land itself. Indeed, trees seem to grow best atop the old Maya structures because they can take root better in the gaps between the stonework than on the jungle floor.

First, picture the forest . . .
A single-file army of ants
biting [leaves of] a mammoth
tree into uniform grains . . .
a choir of seedlings arching
their necks out of rotted tree
stumps, sucking life out of
death. This forest eats itself
and lives forever.

BARBARA KINGSOLVER, *THE POISONWOOD BIBLE* (1998)

The Gulf-coast Toad (*Bufo villiceps*) is one of the most abundant amphibians found in the Selva Maya. The best time to look for frogs and toads is at night, after a drenching rain.

Over the centuries, the jungle has supplanted the temple as sanctuary. Fittingly, tropical forests have often been likened to cathedrals, their towering palms and mahoganies and ceiba trees serving as pillars supporting a leafy ceiling. As a lineated wood-pecker taps out a beat on a hollow tree trunk, a polyglot choir of lesser greenlets, red-legged honeycreepers, and white-breasted wood wrens performs.

The fundamental discoveries of ecology . . . have taught conservationists that saving habitat must come first: Without the sustenance of its environment, a species will diminish to its vanishing point no matter how well it is protected against poachers.

JONATHAN EVAN MASLOW, *BIRD OF LIFE, BIRD OF DEATH*

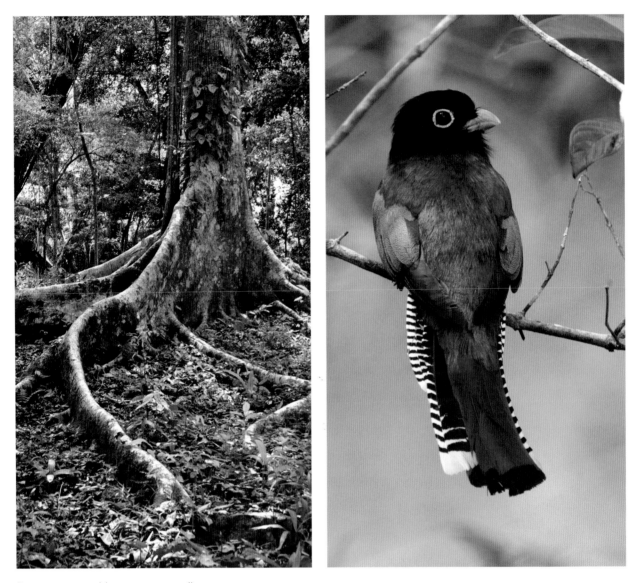

Buttress roots enable trees to grow tall despite the shallow soil of the jungle floor, just a few inches thick atop a bed of limestone.

The Violaceous Trogon male is notable for its beautiful plumage. Trogons nest in holes in trees and feed on fruit and insects. They are cousins of the increasingly rare Resplendent Quetzal.

In the tropical forest, the soil that carpets the impenetrable limestone floor is typically only three to four inches thick. The larger trees need buttress roots—organic angle arms that jut out for several yards in all directions—to keep from toppling. The shallow soil's nutrients come from decaying organic matter, with a huge assist from brigades of ants and termites.

The Maya forest brims with the reasons that people visit here from all over the world: the ancient ruins, the butterflies, the abundance of exotic birds, the frogs and lizards, the hope of seeing a jaguar or other cat. What is significant is not just the variety of rare or endangered species but also the numbers of species and their abundance. Near the water, for example, are five types of kingfishers, from the pygmy to the ringed, as well as ample opportunities to

see each. Although pumas and jaguars and the other cats are hard
to come by, many of the animals, birds, reptiles, amphibians, and
insects that you can see almost any day are sights that most people
see only between the pages of a book or in exhibits in a zoo.

Lost in the quest for the reclusive red-eyed treefrog or a lovely
cotinga is often the magnificence of the jungle itself, tens of thou-
sands of acres of it, with a complicated ecosystem that involves
all sorts of symbiotic relationships. The bullhorn acacia tree, for
example, is home to ferocious ants that will protect it from invasive
vines and bugs—and from humans. Gumbo limbo trees typically
grow near black poisonwood trees, and the gumbo limbo bark pro-
vides an antidote for people who accidentally touch the aptly named
poisonwood.

One reason for this bounty of life is the region's warm climate.
Another is that much of the region has escaped fragmentation,

The Great Curassow (left) and the Crested
Guan (below) are so favored by hunters
that these chickenlike game birds rarely
exist outside protected areas. The male
Curassow is easily identified by the large
yellow knob (called a caruncle) on his
forehead. The Guan is distinguished by
his red neck.

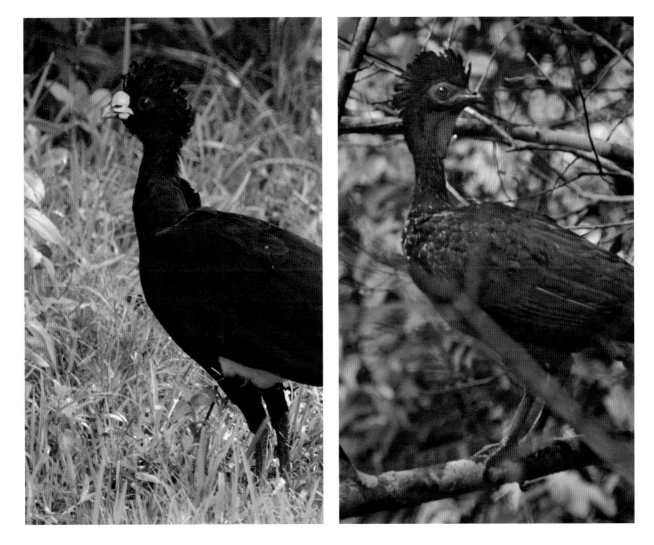

A bird's nest is a bedroom, dining room, sitting room, parlor, and nursery, all in one; for there the young birds sleep, eat, rest, and entertain their guests (if they ever have any), and receive their earliest training.

LEANDER S. KEYSER,
IN BIRD LAND

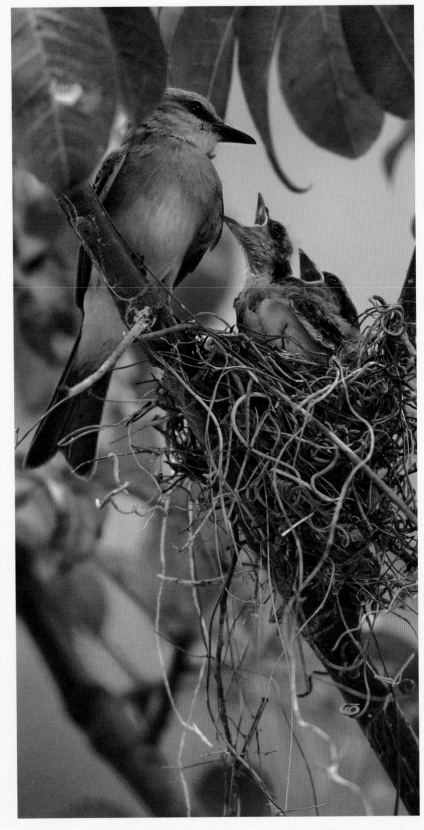

The Tropical Kingbird, a flycatcher with a dark, forked tail, yellow breast, and light gray head, is one of the most ubiquitous birds in the Selva Maya. Its open-cup nest holds a clutch of three or four, who take just over two weeks to incubate and nearly three weeks to fledge.

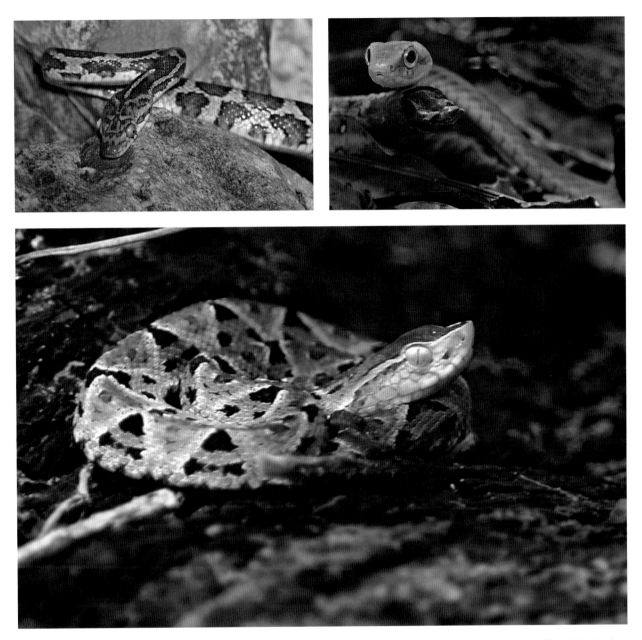

thus far. The more fragmented the jungle becomes, the less the breathing room for an endangered species and the worse its odds of survival. The jaguar, for example, once lived as far north as the United States, but it disappeared as humans developed and populated the Southwest.

The surest way to find what you seek in the tropical forest is to travel with an experienced guide. Guides know the jungle better than you know your backyard. Bring a wish list. You may be surprised just how many species a guide can find and how many plants and insects you'll see that you may not even have known existed.

The Parrot Snake (top left) and Rat Snake (top right) are both nonpoisonous and very valuable in controlling local pests.

The Fer-de-lance is considered the deadliest pit viper in Central America. The juvenile (shown here) is particularly dangerous because it is more likely to release its venom when it bites. It is also known as the Terciopelo and the Yellow-jawed Tommy-goff.

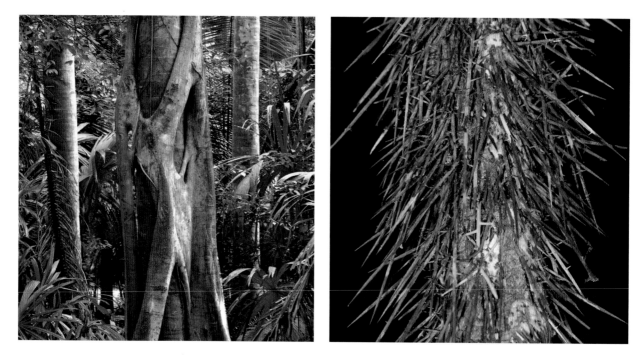

Strangler Figs begin as seedlings that sprout high in the canopy and slowly reach to the ground, wrapping themselves around the trunk of the host tree and eventually engulfing it like a boa constrictor.

The Give-and-take Palm is named for its treacherously spiny exterior and its palliative inner bark, which stops the bleeding caused by the spines.

You can learn more from a guide than merely what to see. You can also learn how to behave in the jungle: disturb nothing, tread softly, listen always, see as much as you can, and speak only when you have something worth saying.

If you walk alone, you should approach the jungle as you would a foreign city, with the paths the equivalent of main thoroughfares. You should keep to the beaten path, and just as you look both ways before crossing a street, you should pay attention in the jungle. Chances of encountering a fer-de-lance or another poisonous snake are slim but not out of the question, and an abundance of give-and-take palms, with their painfully spiky trunks, awaits the careless walker.

The one thing you'll need more in the tropical forest than in a foreign city is serious insect repellent, the daily cologne of a wise person.

You will leave the tropical forest with your own set of memories: a spider monkey clinging to her baby as she crashes from palm tree to palm tree, a crocodile sunning itself by the river, a highly organized work crew of leaf-cutter ants threading its way at your feet along the trail.

The more time you spend in the tropical forest, the greater your opportunities. Like most things in life, what you get out of it depends largely on the effort you invest.

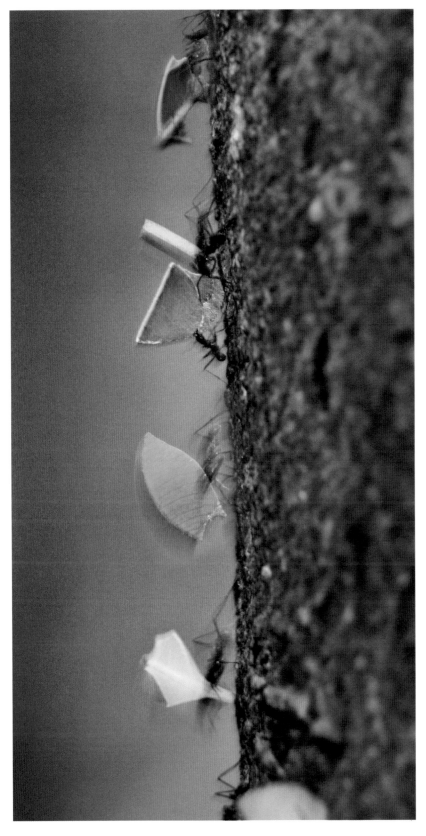

Leaf-cutter Ants help recycle nutrients to the soil. The highly organized ants cut and clean the leaves and bring them bit by bit along well-established routes to their huge underground nests, where they cultivate a fungus that helps decompose the vegetative material.

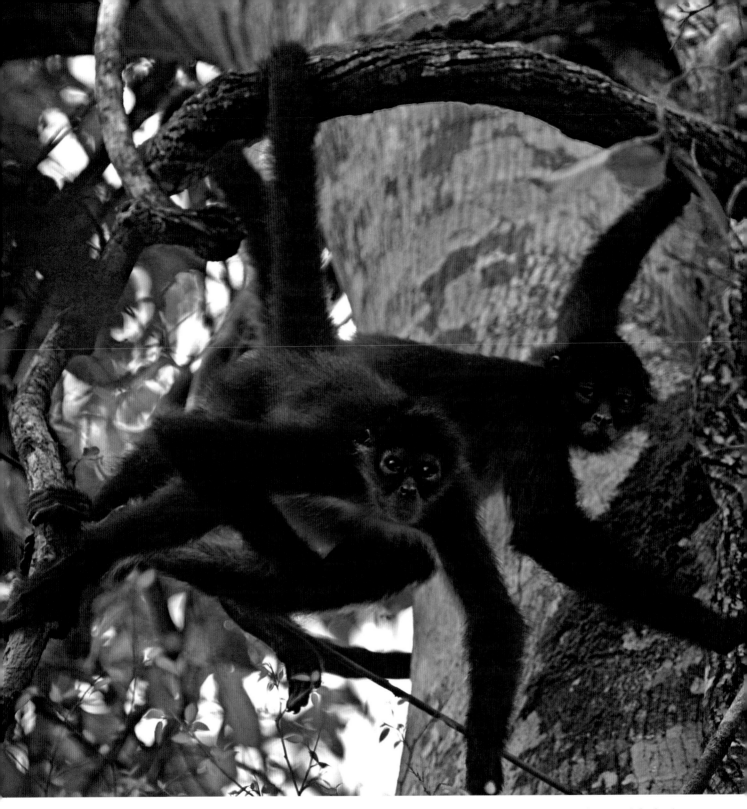

Spider Monkeys like to travel in small groups, splitting up when they search for food. They're fun to watch, but keep your distance. If they feel threatened, their response includes shaking the tree branch and hurling fruit and feces.

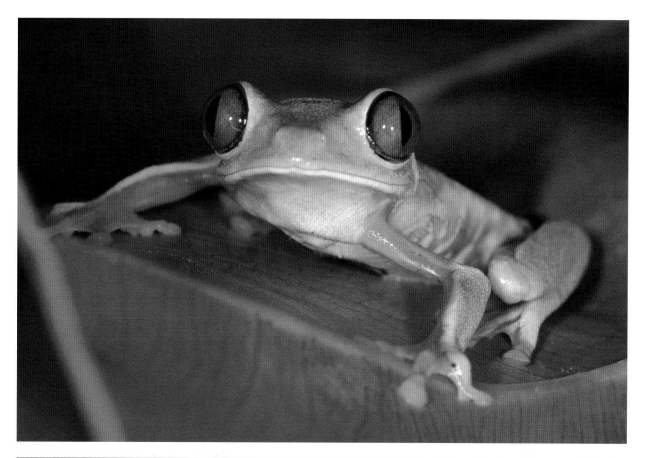

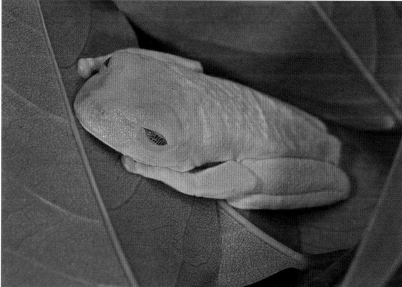

Red-eyed Treefrogs live near water in the Selva Maya. Active at night, these tiny amphibians eat mostly insects. When they sleep, the eyes are recessed and out of sight. The big suction cups on their fingers and toes enable them to stick to leaves. Although they are well-camouflaged when sleeping on a green leaf, their big red eyes and bright legs and sides go on full display when they sense a predator closing in, in hopes that the sudden bursts of color will create enough confusion to allow them to escape.

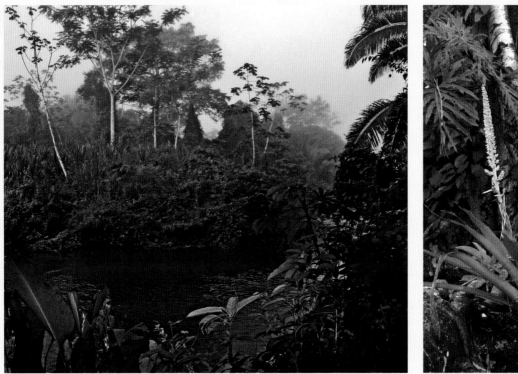

The love of wilderness is more than a hunger for what is always beyond reach; it is also an expression of loyalty to the earth, . . . the only paradise we shall ever know, the only paradise we ever need, if only we had the eyes to see.

EDWARD PAUL ABBEY, *DESERT SOLITAIRE*

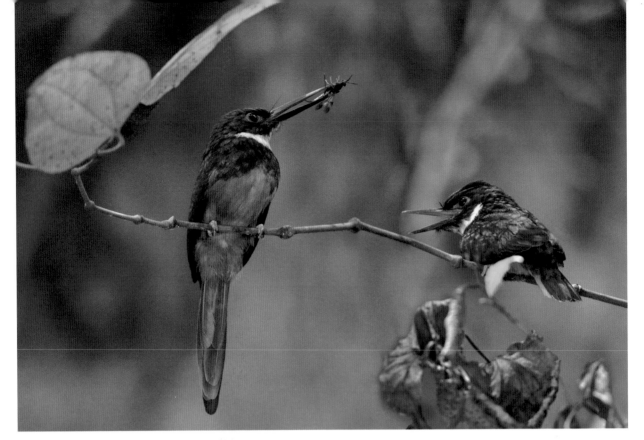

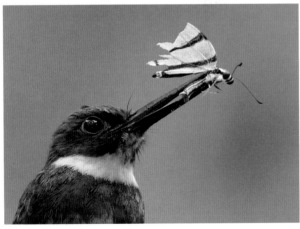

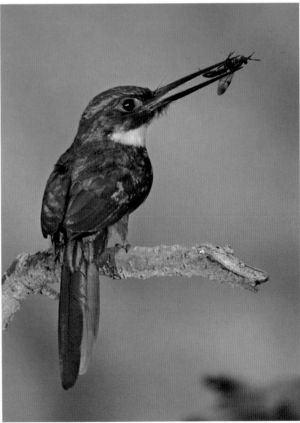

Using an insect as a reward, the female Rufous-tailed Jacamar (top) has coaxed her young male fledgling out of its burrow nest for the first time. He is being encouraged to fly again to get his next snack.

Jacamars can often be seen perched on a branch looking for insects. They'll zip out and nab their prey, then bring it back to the branch to eat. A long bill allows the bird to hold butterflies and other quarry without having the insect's wings flap in its face. The bird removes the insect's wings by beating them against the branch. Before eating the insect or offering it to a fledgling, the bird may have to reposition it (opposite).

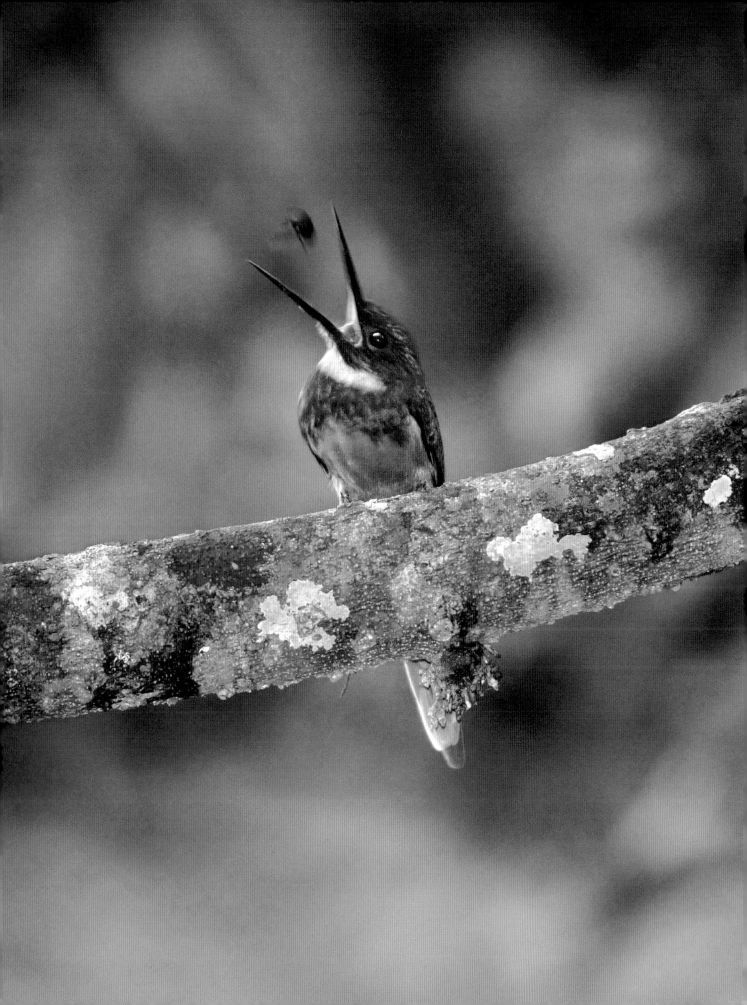

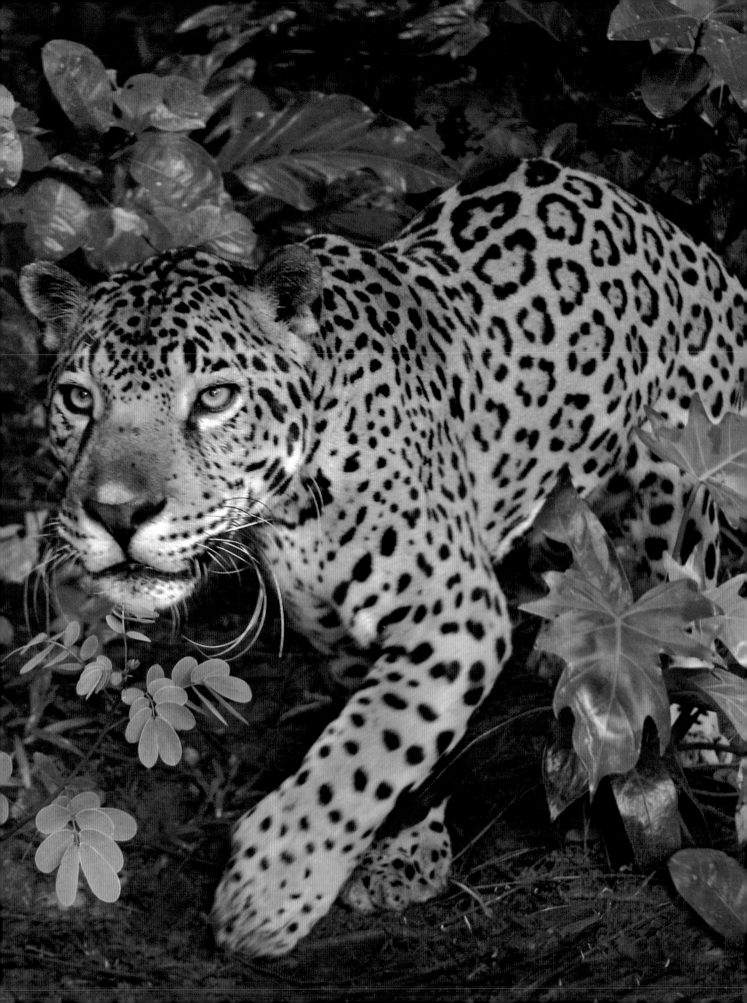

Jaguars and Other Cats

The Selva Maya shelters several kinds of wild cats, including the puma, the ocelot, the margay, and the jaguarundi. But none can compare to the jaguar. This magnificent creature stands atop the food chain, lord of the Selva Maya and the largest cat in the Western Hemisphere. Jaguars are the ideal jungle predator. They are adept at hunting in trees, on the ground, and in the water. They use their cunning to stalk, their speed to surprise, and their powerful jaws to crush all sorts of creatures, except humans. Jaguars are growing increasingly rare, the tragic result of decades of forest fragmentation and illegal hunting.

The jaguar, quite simply, has a star quality that makes visitors travel thousands of miles in hopes of catching just one glimpse of this 130-pound beast, or seeing its tracks on a jungle path.

"Who could not love a jaguar? It's a big, beautiful predator," says Wildlife Conservation Society researcher Carolyn Miller, who has observed jaguars in Gallon Jug, Belize, for more than a decade. "People just seem to have a connection to it. The cleverness, the stealth, the mystique. The jaguar is so much a part of the culture and mythology of the region. To meet up with one of these creatures is to be touched by the essence of wildness, of the wilderness primeval."

The jaguar's beauty begins with its fur pattern of black rosettes on a buckskin background, camouflage for the forest and yet singularly stunning when seen in the open.

Then there are those eyes. All cats' eyes are hypnotic, from the smallest house cat in Canada to the largest lion in Londolozi, but

The jaguar is one of the world's most powerful living creatures, but it has absolutely no control over its own future. Mankind, unsatisfied with his own place in the world, wishes to absorb the place of all other living things.

ALAN RABINOWITZ, *JAGUAR* (1986)

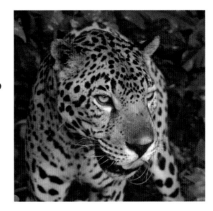

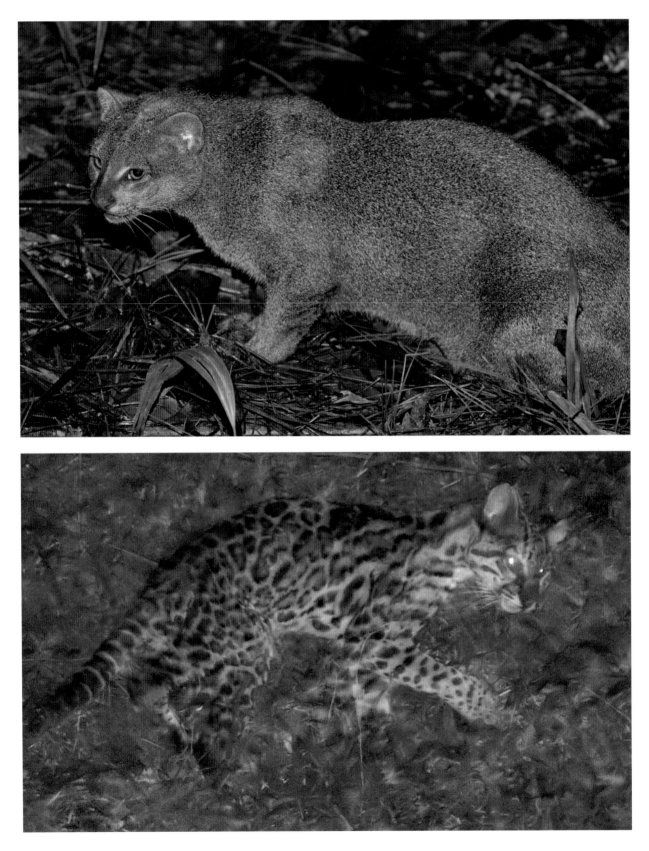

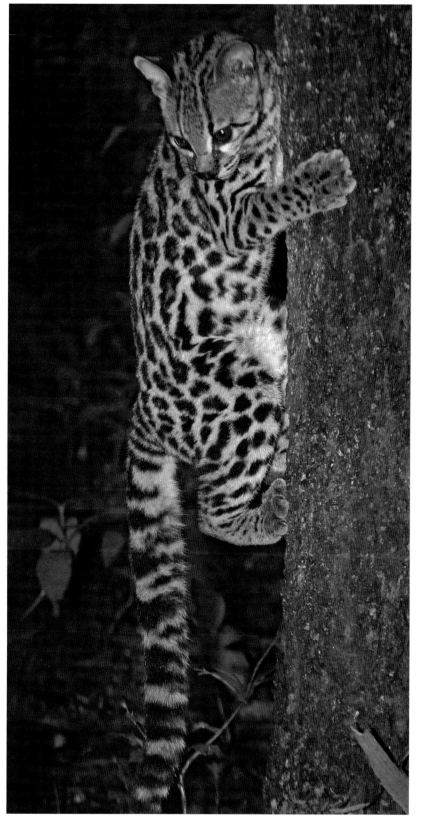

Jaguarundi (opposite page, top): This gray cat has short legs and an elongated body, making it appear almost otterlike. An excellent swimmer, it likes to hunt at dusk, going after such small prey as birds, rodents, fish, and frogs. It has a fearsome ground attack, often racing up to a mile to chase down rodents.

Ocelot (opposite page, bottom): A medium-sized spotted cat, the Ocelot climbs well but typically feeds on the ground of the forest at night, with a diet that ranges from opossums to birds and reptiles. Ocelots occasionally hunt in pairs. It is the most frequently seen spotted cat.

Margay: Slightly larger than a typical house cat, the Margay is the smallest of the wild cats of the region. These nimble climbers live in the jungle in trees. Thanks to their long claws and dexterity, they are the only cats that can descend the trunk of a tree head-first, like squirrels. The Margay's thick tail is almost as long as its body.

the jaguar's ratchet up the intensity a notch, as though made of electrified amber and, depending on how the light hits them, an occasional flash of green.

The sense of mystery surrounding the jaguar endures on all levels. First, because El Tigre is secretive and often nocturnal, it is seldom seen for any length of time, even though fleeting daytime glimpses are not uncommon in areas where it is well protected. It's little wonder, then, that the two most prevalent types of jaguar photographs are those taken at zoos and game reserves, and those taken with camera "traps" (heat-sensitive and motion-sensitive stationary cameras set up in the forest and checked at regular intervals).

The big cat is a master of stalking. Carolyn Miller of the Wildlife Conservation Society tells of the time she set camera traps with her husband in the forest in Gallon Jug, only to discover later from the photos and data from the cameras that a jaguar had been following them, just forty yards away. After they would set a camera trap, the jaguar soon walked past, headed in the same direction they were. Yet they never saw or heard it.

The jaguar is magical on a spiritual level as well. The jaguar was sacred to the ancient Maya, who placed it at the center of their mythology. To them, the jaguar lived in the underworld each night, only to be reborn each day as the Sun god, who traveled across the sky during the day and descended once again. The spots on the jaguar's skin came to represent the stars of the night sky.

Even though *Panthera onca* is a protected species, it is often in jeopardy, especially if a nearby human population has killed off

The Jaguar was an important creature in Maya mythology. Its likeness adorns temples, sculptures, and other artwork. The sculpture here is a double-headed jaguar throne that sits in front of the Governor's Palace at Uxmal. A statue of a red Jaguar is located inside Chichen Itza's famed El Castillo.

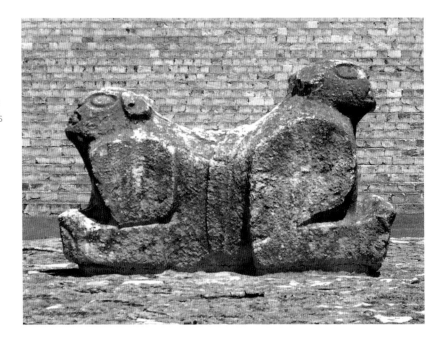

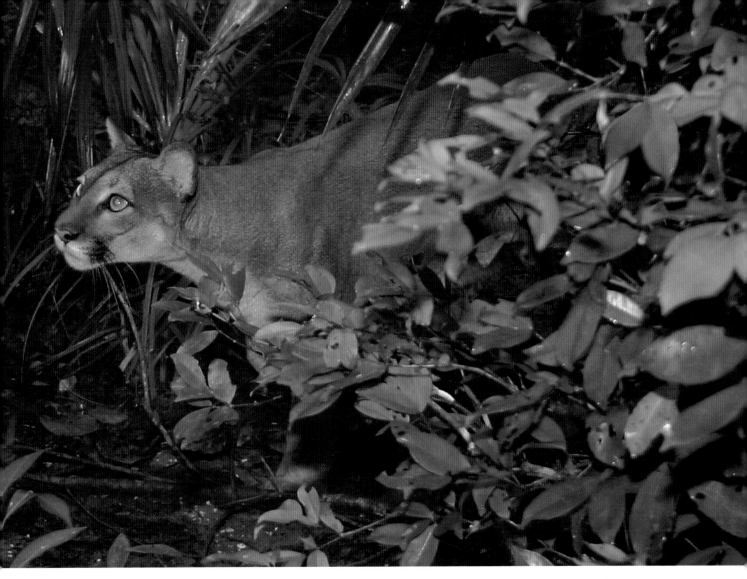

the other wildlife and there aren't many natural prey available as a result. The jaguar is then more apt to go after the local livestock, and farmers kill it.

Dozens upon dozens of these so-called problem jaguars are killed legally in the Selva Maya each year. There's also an illegal trade in jaguar cubs, jaguar skins, and jaguar meat.

What's the big deal? Why does the jaguar's long-term survival matter? Wildlife biologists say that if an area loses the large predators, the entire composition and balance of the forest is ultimately thrown out of whack.

You've heard about the canary in the coal mine. It's the same with this magnificent cat in the jungle.

Puma: In the Selva Maya, the Puma is second only to the Jaguar in size, and in some instances it may even be slightly larger. The Puma is not only extremely agile but it can also swim and climb. Its range extends all the way from the Yukon to southern Argentina. The Puma is also called Mountain Lion, Cougar, Panther, and Catamount.

*If there is magic on this planet,
it is contained in water.*

LOREN EISELEY,
THE IMMENSE JOURNEY

Opposite page: White Butterflies

Little Blue Heron

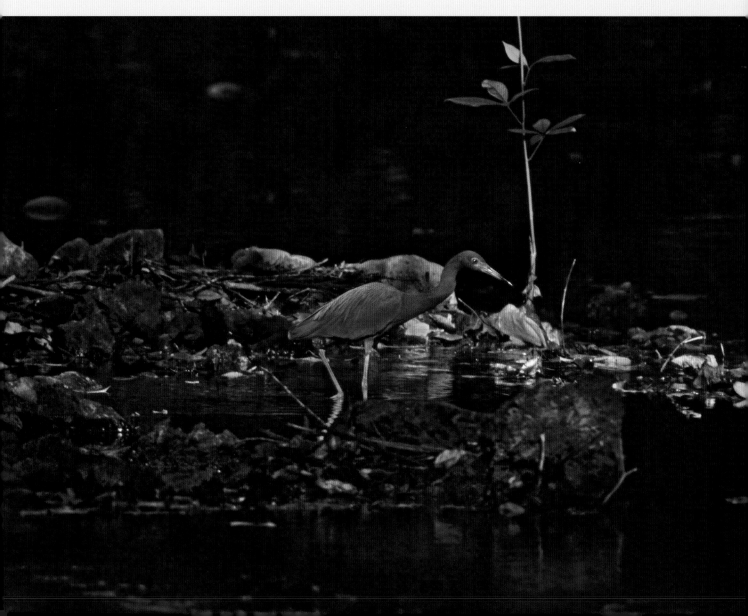

By the Water

t is a fundamental contradiction of the rainforest: Although moisture abounds, water—nature's life-blood—is often scarce. Most of the Selva Maya sits atop a bedrock of porous limestone, topped by a few inches of soil. Rain tends to evaporate into the hot air, percolate into the limestone, or get absorbed by all that vegetation.

That is why when you find water—rivers, lagoons, wetlands, lakes, bajos (depressions that collect water during the rainy season), even puddles—you'll likely find creatures as well. Since there can be a bit of breeze and shade by the water's edge, and since the sound of water will often mask the sound of human footsteps, this is an ideal place to absorb the region's wonders.

Rivers and streams are particularly fruitful. Crocodiles and turtles lurk here. Jaguars gravitate here in search of a meal, using their agility to catch fish and their powerful jaws to crack through a turtle's shell. Agami herons and an array of kingfishers go angling here. Hummingbirds bathe here, and so do warblers. Insects breed here, providing a great food source for frogs, birds, and bats.

Tropical forest wetlands are fertile grounds for all sorts of waders: rails, egrets, and all manner of herons. Because the marsh habitat isn't as thickly vegetated as the forest, these birds are much easier to spot.

Perhaps the most amazing resident of marshes, lakes, and streams is the flashily feathered northern jacana. According to *The Bird Almanac*, the chocolate-colored jacana has the longest toes relative to body length of any bird in the world. Those four-inch-long

To the naturalist who wishes to see the wild land at its wildest, the advice is always the same—follow a river.

ATTRIBUTED TO
EDWIN WAY TEALE

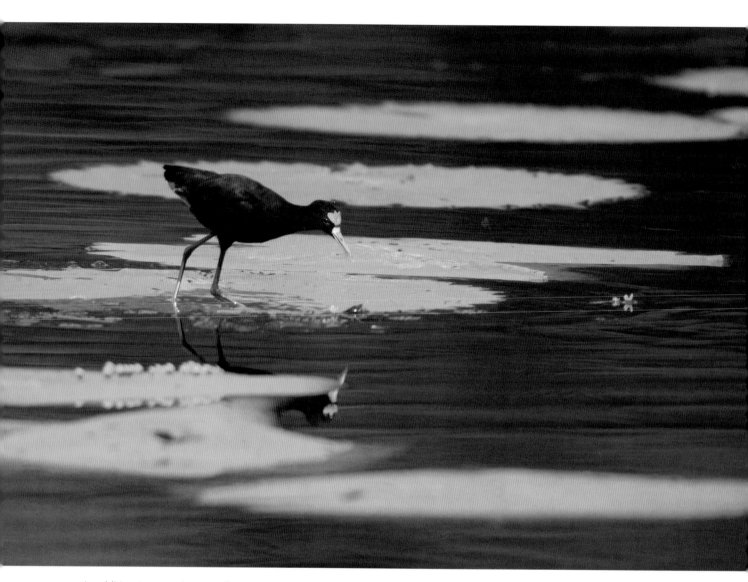

In addition to appearing to walk on water, Northern Jacanas reverse their rearing duties. Males build the nests, incubate the eggs, and take care of the young.

toes form tripods that distribute the bird's weight so efficiently that it lives atop lily pads and other floating vegetation. The high-stepper walks across the surface so nimbly that it sometimes appears to walk on water.

Since surface water can be scarce in the jungle of the Maya, even puddles can be big deals. Not only do all sorts of birds drink or bathe in the puddles, but the puddles also sustain miniature eco-systems of sorts.

As you travel farther north on the Yucatan Peninsula, the jungle canopy gives way to scrub forest, and surface water becomes so rare that rivers, streams, ponds, and lakes are nowhere to be seen. Instead, particularly near ancient Maya sites, you'll find cenotes, which range from small sinkholes to deep basins filled with rainwater.

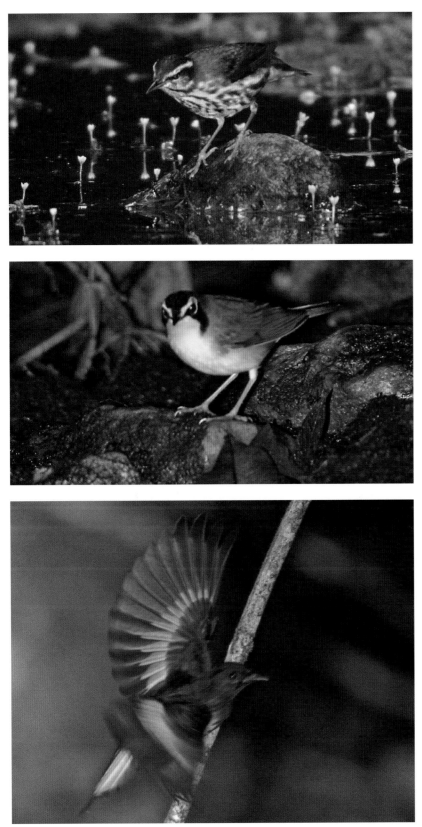

Migrant Warblers congregate by the water in morning and late afternoon (top to bottom): Louisiana Waterthrush, Kentucky Warbler, and American Redstart.

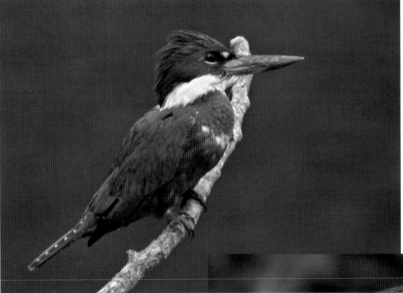

Kingfishers range in size from large to small (top to bottom): Ringed, Green, and Pygmy. The Ringed Kingfisher can be up to 16 inches long, whereas the Pygmy is only about 5 inches. Kingfishers eat mainly fish, which they hunt from perches or by hovering.

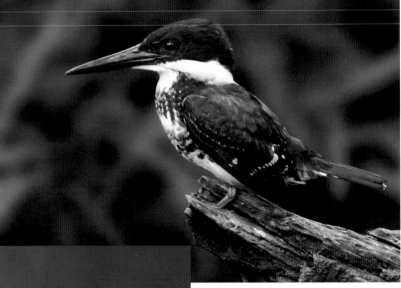

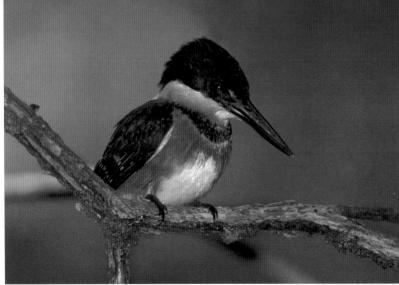

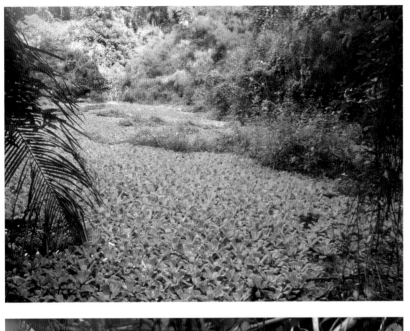

The lettuce-covered pond once served as a water supply for the ancient Maya. Water attracts creatures large and small, from dragonflies to crocodiles. Crocodiles, once hunted for their hides, have been making a comeback ever since they became protected species in 1981.

The cenotes are the result of centuries of erosion from mildly acidic rainwater, which has eaten away the limestone and created networks of subterranean rivers and caves. When the roofs of these caves collapse, they expose substantial underground water supplies. The most famous is the Cenote Sagrado at Chichen Itza in the northern Yucatan. The Blue Hole, in central Belize, is another.

The other primary water source is precipitation. The rainy season runs roughly from June to December and plays a crucial role in the life cycle of treefrogs and other creatures. Many treefrogs live in the canopy most of the time, but during the rainy season they descend to ponds to breed. For the Maya, who had to endure long dry spells, the rainy season could not come soon enough. Its arrival, marked by the appearance of frogs, was a time of celebration.

Birds to look for on the marshland and water include the Gray-necked Wood-rail (with chicks), Bare-throated Tiger-heron (bottom left), and Yellow-crowned Night-heron (adult and juvenile, bottom right).

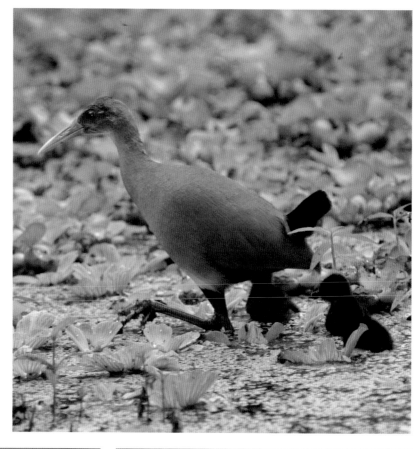

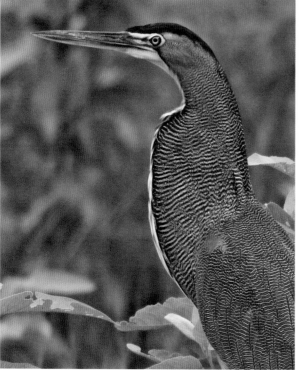

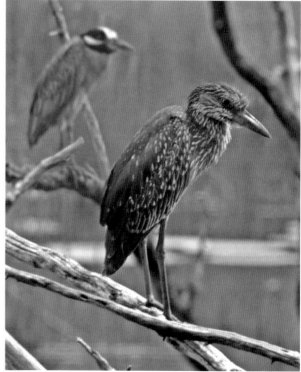

Great Egret

*T*he marsh, to him who enters it in a receptive mood, holds, besides mosquitoes and stagnation, melody, the mystery of unknown waters, and the sweetness of Nature undisturbed by man.

CHARLES WILLIAM BEEBE, *LOG OF THE SUN*

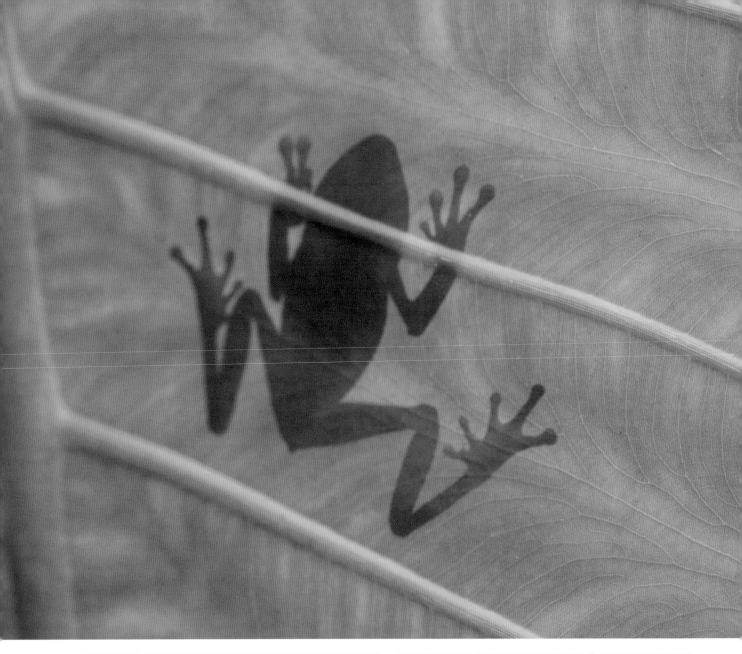

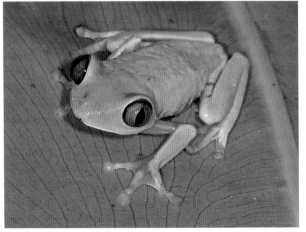

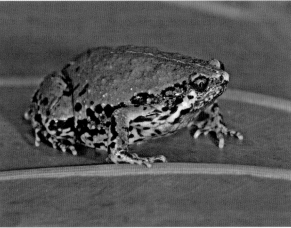

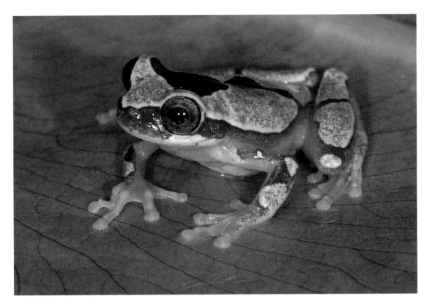

Frogs come out en masse during the rainy season. Treefrogs remain mostly in the canopy, except to breed. At left are the Hour-glass Treefrog (top), the terrestrial White-lipped Frog (center), and the Mexican Treefrog (bottom).

Opposite page: The Red-eyed Treefrog (left) and the Sheep Frog (right). From above, the Sheep Frog looks like a leaf.

Cattle Egrets perch in a flooded
grove of trees.

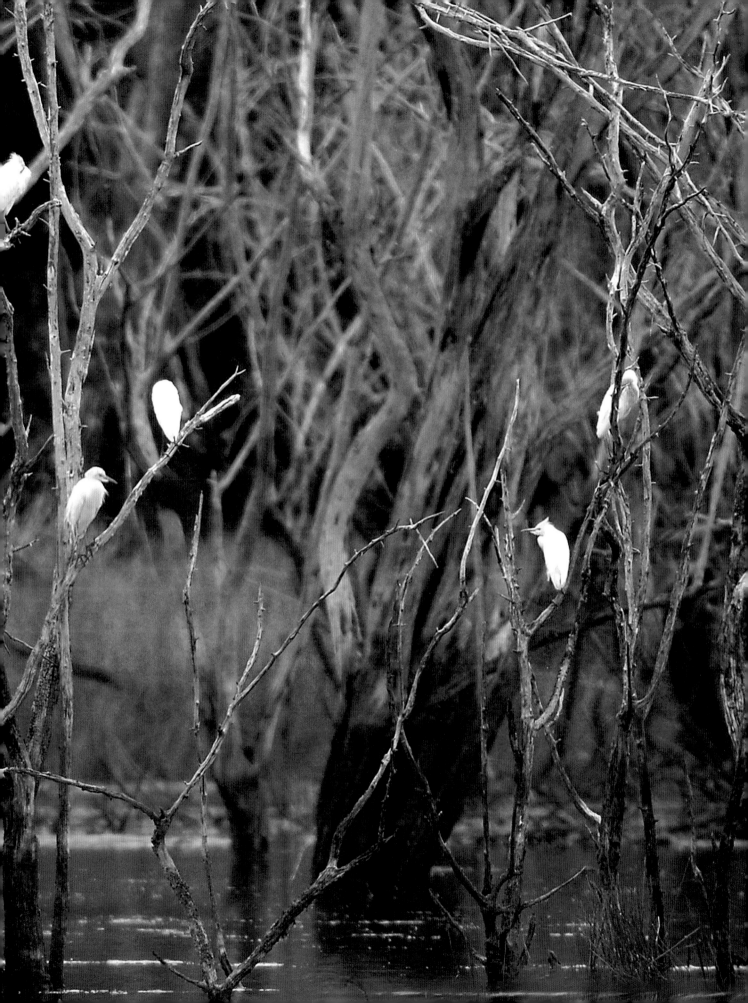

The Jaguar Temple at Lamanai is near the New River Lagoon in Belize. "Lamanai" is Mayan for "submerged crocodile." Maya occupied the site for more than two thousand years, starting in about 500 B.C.

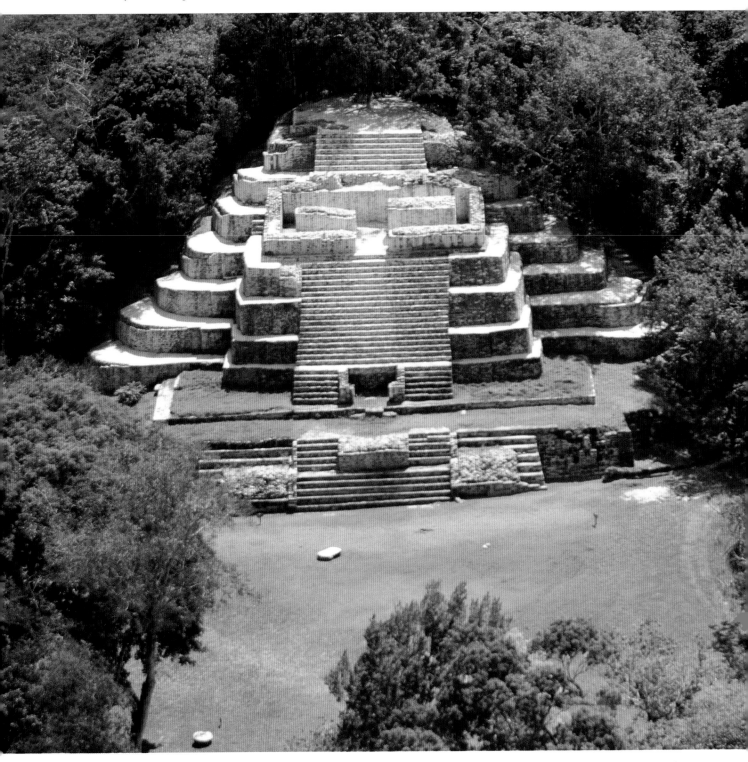

The Maya Presence

Picture the jungle of the Maya as a vast canvas that Mother Nature has employed to paint a spectacularly beautiful landscape. Then imagine this: If you could peel away centuries upon centuries of history, you'd find an altogether different image, a portrait of one of the greatest ancient civilizations in the world.

Across the jungles of the Yucatan and Guatemala's Peten, archaeologists have removed centuries of overgrowth and found a network of Maya settlements large and small. These range from the enormous ancient city of Tikal in Guatemala to Calakmul and Chichen Itza in Mexico to Lamanai and La Milpa in Belize. Along the way, the archaeologists have also uncovered a profusion of information about the Maya, who ruled much of Central America for more than a thousand years.

From before the time of Christ to well into the Dark Ages, a time when much of Europe could barely tie its shoes, the Maya flourished amid jaguar and jungle and incorporated them into their core mythology and beliefs. The towering ceiba tree, for example, was sacred because the Maya believed that it grew through the center of the universe, connecting heaven to the underworld. In the tree's crown sat Hunab-Ku, god of creation, overlooking his work.

To appreciate fully the jungle of the Maya, you must appreciate the ancient Maya themselves, who imbued the forest with deeper meaning even as they built a complex civilization in the thick of it.

They were outstanding mathematicians, astronomers, artists, and architects. They created their own written language using

[To the] Maya, the world was a complex and awesome place, alive with sacred power. The power was part of the landscape, of the fabric of space and time, of things both living and inanimate.

MARY ANN MILLER AND LINDA SCHELE, *THE BLOOD OF KINGS* (1986)

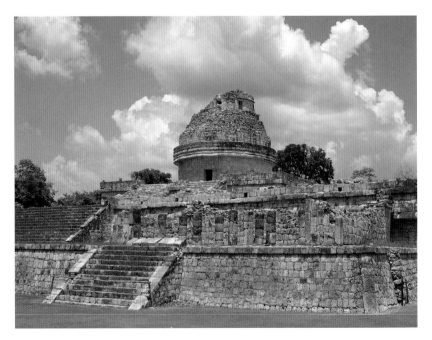

El Caracol (the Snail) at Chichen Itza served as an astronomy observatory, with circular architecture and a spiral staircase that gives the structure its name. The rectangular openings in the tower were used for making celestial calculations.

glyphs, which combined pictorial representations of humans, animals, and other creatures with abstract symbols. They invented the concept of zero and constructed an elaborate system of numbers that could be calculated into the millions.

With great precision, they charted the night sky and developed their own complex and uncannily accurate calendar. The astronomer-priests could predict solar and lunar eclipses, as well as the celestial movements of the planet Venus.

They created elaborate art from stone, ceramics, shell, wood, and jade. Out of limestone, they built incredibly straight and advanced roads called *sacbes,* which stretched up to sixty miles. They developed a flourishing empire of connected city-states and regional states that traded with one another. They carved limestone into immense blocks and built pyramids tall enough to scrape the clouds and observe the universe, temples that jut above the jungle canopy to this day.

What makes these achievements even more noteworthy is that they thrived in a region inhospitable to humans. In the book *Maya,* Nobel Prize–winning author Miguel Angel Asturias of Guatemala provides this perspective: "The admiration one feels in front of these monuments is infinite . . . in the midst of these flooded lands, in the humidity and the heat, wizard architects threw tons of stone into flying edifices."

Maya architecture is all the more remarkable because all those immense and towering temples at Chichen Itza, Tikal, and elsewhere were built with manual labor, without the aid of the wheel or draft

Maya relic

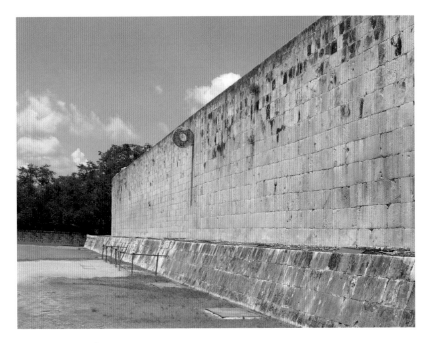

The ball court at Chichen Itza, more than 184 yards long, is thought to be the largest of its kind. The acoustics are such that you can clap your hands at one end of the court and hear the echo over and over.

animals, using limestone blocks that could weigh hundreds of pounds. The stone was quarried nearby, but how it was transported or raised into place is still a matter of speculation.

Dr. Peter Schmidt, in charge of the current excavations at Chichen Itza, says the Maya likely used logs to roll the limestone blocks to their destination—much like a modern conveyor belt— then used ramps and levers and brute muscle to lift the blocks into place. "In a way, we experience similar problems in our restoration work because we don't have sophisticated machinery either," he says. "The combined force of a lot of people pulling in the same direction can do quite a bit."

Early archaeologists thought the Maya to be peaceful philosopher-farmers, but additional research has shown that they lived in city-states that sometimes went to war against one another. At many of the sites, archaeologists have uncovered the legendary Maya ball courts, used for a game that was a hybrid of basketball and soccer, often with a deadly twist. Many of the games were ceremonial, pitting victors against their vanquished enemy. The outcome of those games was established beforehand, and so was the losers' fate, beheadings on a sacrificial altar.

All across the jungle of the Maya, archaeologists have scraped away centuries of overgrowth in key places and mapped out entire Maya centers. But many antiquities still lie buried. At major sites, many temples and other structures have been uncovered and restored. At smaller sites, however, archaeologists typically examine just 5 percent of what is there and do not try to restore it.

At Chan Chich, a Maya temple (opposite page) remains buried by centuries of overgrowth. The two slots in the middle of the ruin are looter's trenches. Inside the lower looter's trench (above right), the Maya's signature red paint has endured for more than a thousand years. The cup (above left) and bowl (right) are among the artifacts that survived the looting.

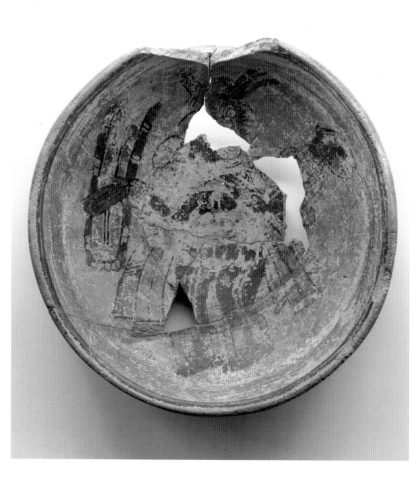

Take the town-sized sites of Punta de Cacao and Chan Chich in northwestern Belize. "What we're doing," says Professor Hugh Robichaux of the University of the Incarnate Word in San Antonio, Texas, "is getting a somewhat random sample that we can use to generalize about how it all was." That's why ancient Maya structures at more sites haven't been exposed and restored. It would be arduous, time-consuming, and expensive, with no guarantee of gaining much information.

The research at each site forms a piece of a larger puzzle. What is known, from artifacts and architecture across the Selva Maya, is that the sites were all connected. The Maya communicated through a common written language and transferred their knowledge as well as their goods. Granite from the Maya Mountains of Belize, for example, was used for grindstones found at sites more than fifty miles away.

At least one great mystery remains: What calamity befell the Maya in the Late Classical period, around A.D. 900, that caused a large number of centers throughout the Selva Maya to become

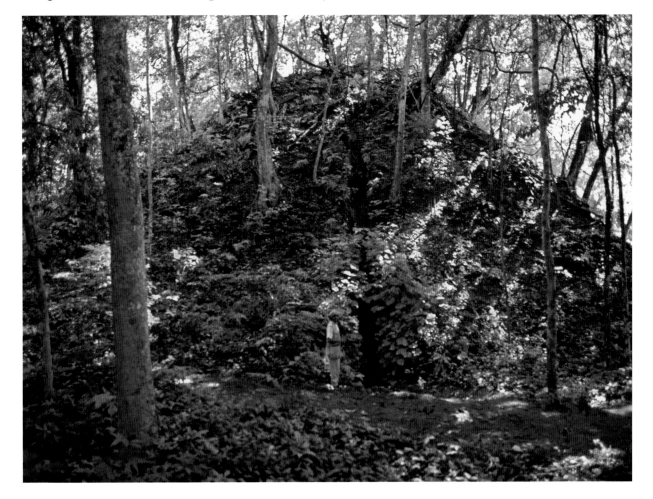

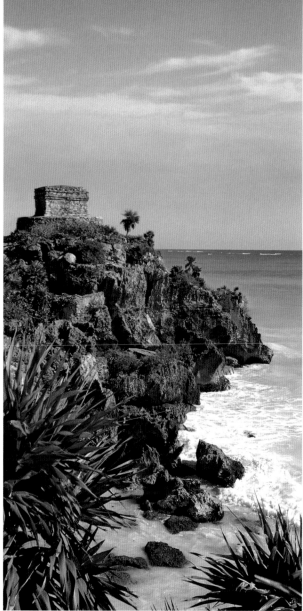

Chichen Itza's Nunnery complex features buildings with corner sculptures and bas-relief patterns honoring Chac, the god of rain, an important god to the water-dependent Maya.

Tulum, overlooking the Caribbean Sea in eastern Yucatan, is the most popular Maya site in the Yucatan, because of its magnificent setting and its proximity to Cancun.

uninhabited? Scientists and archaeologists are still trying to piece together what happened, and theories range from disease to deforestation to overpopulation to drought to civil war. One could argue that they are all related to the water supply.

The Maya tamed the forest, but it ultimately played a key role in their fall from power. The Maya, it seems, had a contradictory relationship with nature. Although their temples and artwork are adorned with jaguars and serpents and other creatures of deep religious significance, the construction of those massive temples helped destroy the jungle nearby.

The Maya invention of plaster, created when limestone was burned into powder and then mixed with water, provided the

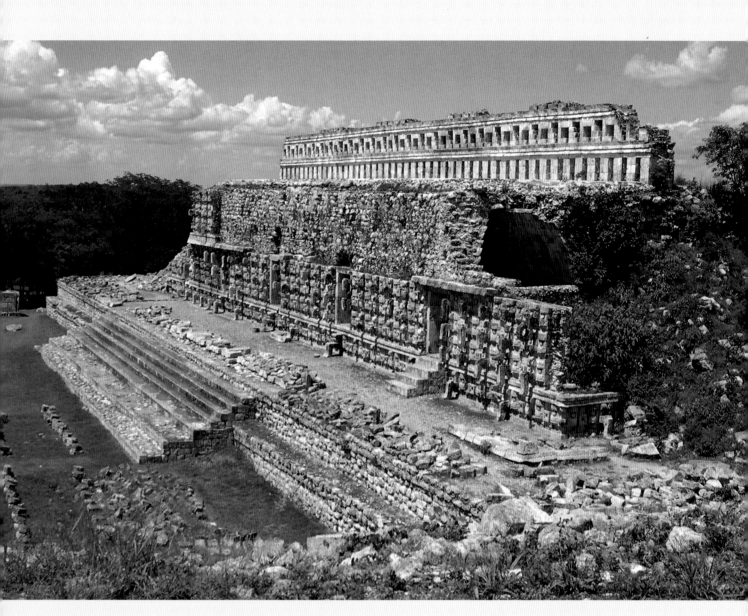

The Maya site at Kabah, near Uxmal in
northern Yucatan, features the fifty-yard-
long Palace of Masks. The masks, carved
in limestone and covering the front
facade, represent Chac.

*The more we investigate the relics left by this
remarkable people, the more we realize that we
have yet scratched the surface of their knowledge of
astronomy, physics, arithmetic, and art.*

THOMAS GANN, *ANCIENT CITIES AND MODERN TRIBES*

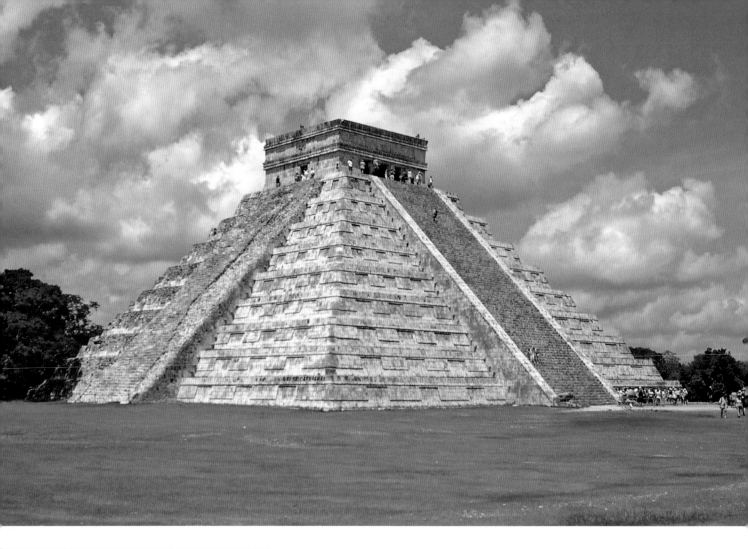

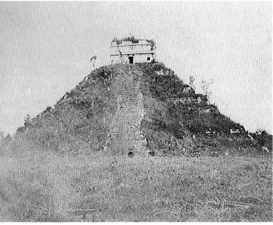

mortar for these ancient skyscrapers. Maya buildings were typically covered with massive amounts of plaster and painted a clay red.

When you look at enormous Maya centers such as Tikal and consider the amount of maize that had to be grown to feed tens of thousands of inhabitants, as well as the amount of plaster required to cover all those temples and other structures, you get a sense of how much forest must have been leveled.

The destruction of forest touched off all sorts of repercussions, from aggravating droughts to eroding the thin topsoil used for agriculture. Throw in that other crucial variable, water, and the Maya's edifice complex could well have contributed to their decline. In short, the land and water supply could no longer sustain the population.

After leaving Guatemala's tropical forests, the ancient Maya lived on for several centuries in Chichen Itza, Uxmal, Tulum, and other Yucatan sites, even though water was scarce there as well. Proud descendants of the Maya still abound across Mexico and elsewhere, but the Maya's age of empire is long over, carved for eternity in stone.

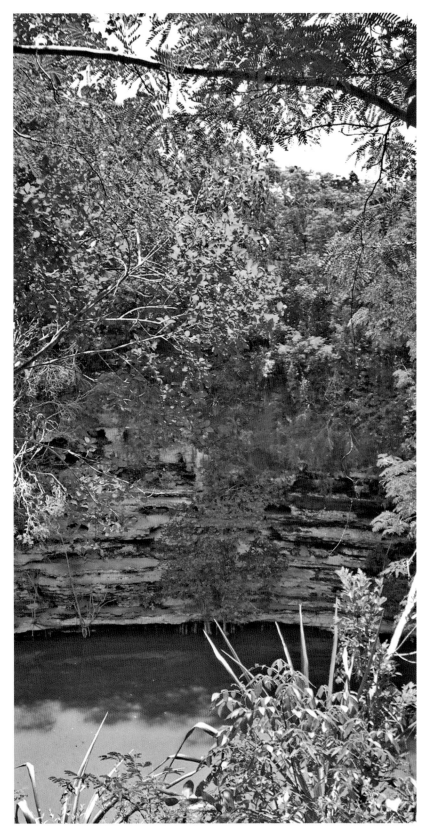

El Castillo (the Castle) at Chichen Itza, shown here in the late nineteenth century (opposite, bottom) and the present day (opposite, top), exemplifies Maya excellence in architecture, art, astronomy, and mathematics. It was constructed with such precision that during the spring and autumn equinox, the rising sun silhouettes the steps on the north side in a sequence that makes it appear as though a snake is undulating down the pyramid.

The Maya at Chichen Itza relied on several cenotes (Chichen Itza means "mouth of the well of Itza people") for their water and used Cenote Sagrado ("sacred cenote") for ceremonial purposes, including human sacrifices in times of drought.

The main plaza at Tikal is flanked by the
North Acropolis and Temples I and II.

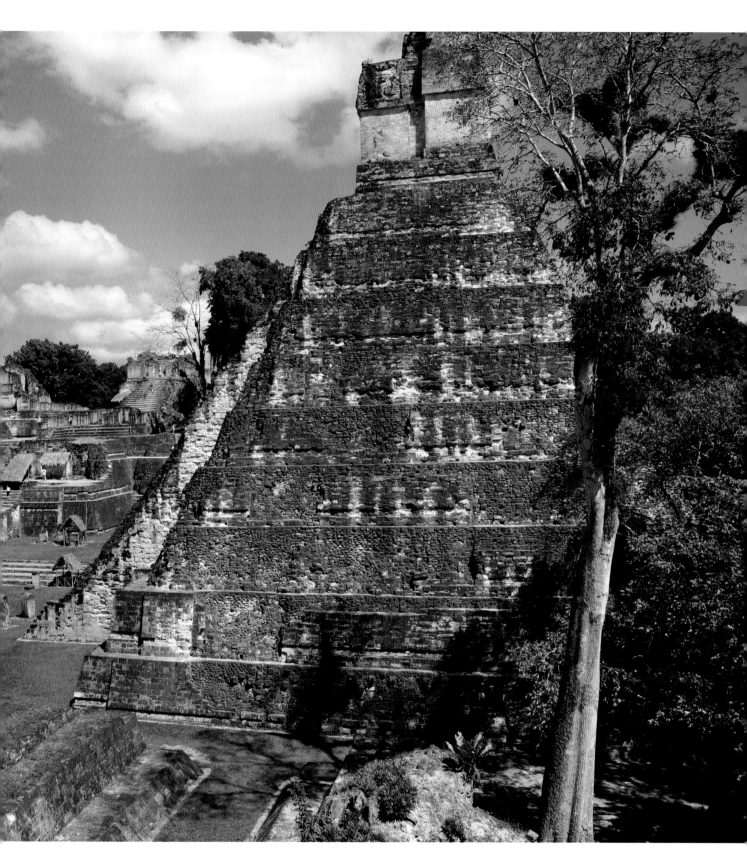

NINE

Camouflage and the Art of Seeing

hen visitors first walk into a tropical forest, they're often surprised by the apparent lack of activity. They may hear a bird or two, but after all the enchanting photos they've seen of toucans and monkeys and jaguars, and after all the magazine articles they've read about how tropical forests are home to so many of the world's species, the forest primeval can be the forest paradoxical.

Here's why. Many creatures are rare, and the forest is vast. A few creatures, notably the jaguar, need large territories to survive. Even if a cat is in the area, it may be half a mile away. Many creatures live in the canopy. It's often hard to see them, especially if they aren't moving.

The forest undergrowth can be thick, especially around the edges, with an assortment of vines and undergrowth and roots. At times you can't see farther than a few feet in front of your face, and the canopy makes things worse by reducing the amount of light. Just because you can't see a creature doesn't mean it is not there. To survive, most go out of their way not to be seen. Many are elaborately camouflaged, so you may not see them even when they are inches away. At first glance, a yellow sulphur butterfly resembles a falling leaf. An insect that is appropriately dubbed the walking stick looks like a twig.

Then there are creatures such as the morpho butterfly, utterly schizophrenic in its colors. In flight, its wings flash a marvelous blue. But when it lands, those wings fold up and the well-camouflaged undersides are displayed.

This forest is a vivid web, woven from the thousands of bizarre activities, a stunning variety of ways of living that together make the forest function as a whole. Most of these activities happen secretly and quietly, hidden by a thick green curtain or by their miniature scale.

CHRISTIAN ZIEGLER,
A MAGIC WEB (2002)

A moth keeps a low profile.

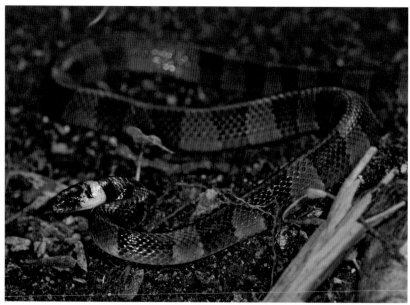

One of several species of False Coral Snakes, which discourage predators by mimicking the more dangerous, poisonous species.

The Yucatan Gecko camouflages itself by masking its shape with a disguise of bold patterns.

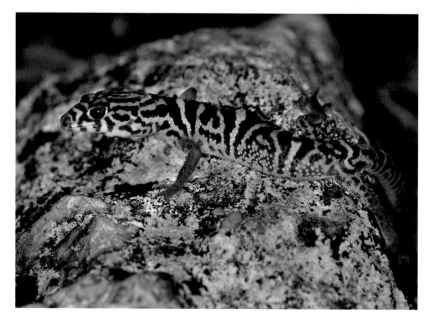

Other creatures take more exotic approaches to camouflage. The survival technique of the false coral snake, for example, is to resemble the highly poisonous coral snake. Along the same lines, many butterflies that are not poisonous to birds (their main predators) resemble butterflies that are toxic.

Here's how to improve your odds of seeing these creatures:

• Timing is everything. No matter where in the world you are, prime viewing time is early morning, when creatures are busy foraging for food. Local birds have been sleeping. Migrants have often been

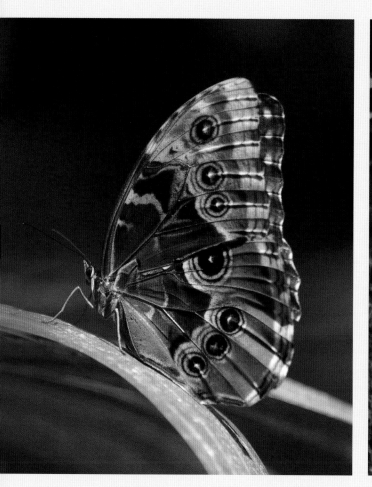

The Morpho Butterfly has a split personality designed to confuse predators. The underside of the wing is camouflaged to blend in with the forest. In flight, the wings open to display an iridescent blue.

*W*hen on the ground or on a tree, morphos are cryptic, but they are (to put it mildly) obvious in the air.

JOHN KRICHER, *A NEOTROPICAL COMPANION*

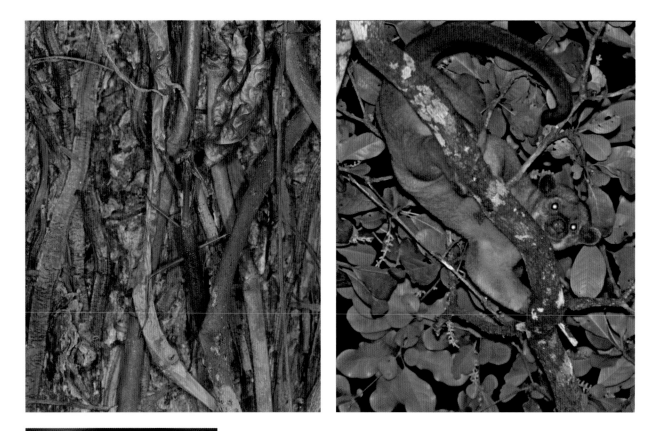

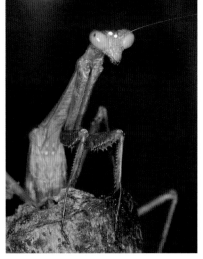

Walking Sticks and other insects are so well disguised that you may miss them even when they are right next to you (above and top left). In profile, however, they are hard to miss.

traveling. All have bellies to fill, and the early birder catches the worm-eating warbler. Conversely, you have to go out at night to see many species. A headlamp or flashlight can reveal a creature's eye shine, which makes locating it a lot easier. Those twinkling pairs of tiny jewels all over the grounds are spiders. Those big eyes you see up above belong not to a monkey but a nocturnal mammal called the kinkajou.

• Think location, location, location. Prime viewing spots are near the water (where the creatures come to drink and bathe) or by fruiting or flowering trees (where creatures come for nourishment).

• Guides are helpful because they know when and where to look. Not only do they know from experience where a crocodile or a red-capped manakin or a hummingbird's nest is most likely to be, but they also share information on the latest sightings with other guides.

Above all, you will increase your odds of seeing creatures by treating the forest with reverence, beginning with walking and talking softly, if at all.

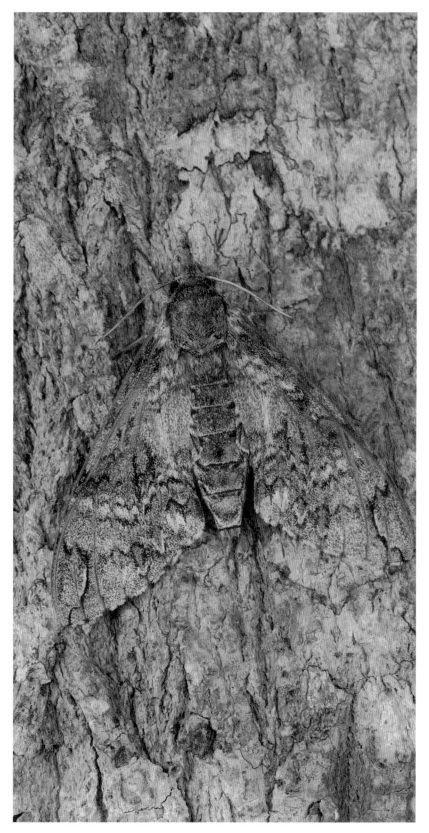

Opposite page, top right: Kinkajous, also known as Nightwalkers, live in the canopy and forage for food at night. The best way to see them is with a flashlight, which picks up their eye shine. Often mistaken for monkeys because of their prehensile tails, Kinkajous are actually members of the raccoon family.

This moth blends in with the tree bark even better than it first seems. Look closely and see how far down the wings extend.

CAMOUFLAGE AND THE ART OF SEEING 93

To look at the jungle up close is to discover a world of lizards, millipedes, and lustrous feathers (in this instance, from an Ocellated Turkey).

One reason so many people are afraid of snakes, even though most (like this Boa Constrictor, opposite page) are not poisonous, is that they are so hard to see that they tend to startle the unwary.

Meet *Bufo marinus,* better known as
the Marine Toad or Spring Chicken. The
largest toad in the western hemisphere,
it has glands behind its eyes that give
off a milky toxin powerful enough to kill
predators as large as dogs if they ingest it.

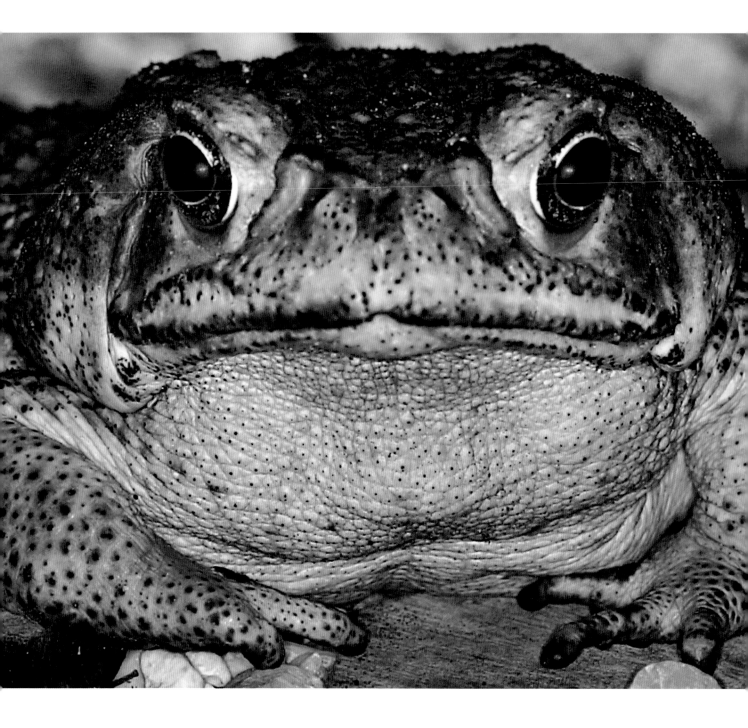

Cool and Unusual

ne February day at the Gallon Jug Escarpment in northwestern Belize, a raft of birds descended on the same tree to eat ripe berries. Sharing that tree were such splendid birds as keel-billed toucans, an emerald toucanet, a masked tityra, and two lovely cotingas. On a nearby tree was a pair of ornate hawk-eagles—mating, no less. You could spend a month in the Selva Maya and consider yourself lucky to see any of these birds. Yet there they were, within minutes of each other, within a few feet of each other.

Although this avian confluence was something of a rarity, the jungle of the Maya is a region where the unusual can be commonplace. The more time you spend here, the more you realize how exceptional the breadth of nature is, from the powerful raptors soaring above the canopy to the vast assortment of plants, creatures, and happenings that too often go unseen or unnoticed.

Many visitors are so intent on seeing exotic birds and mammals that they overlook the jungle's exotic plants and insects. After all, it is more exciting for most people to tell friends back home that they saw toucans, Maya pyramids, and fresh jaguar tracks than to try to describe some of the strangest plants and fungi they've ever laid eyes on. These include bromeliads, orchids, and other epiphytes unique to the New World. They literally grow on trees. The odd plants and bugs and fungi may not be a main attraction of the Maya jungle, but they are integral to the intricate web of life that combines to form the tropical forest.

In all things of nature, there is something of the marvelous.

ARISTOTLE, *THE NATURE OF ANIMALS* (350 B.C.)

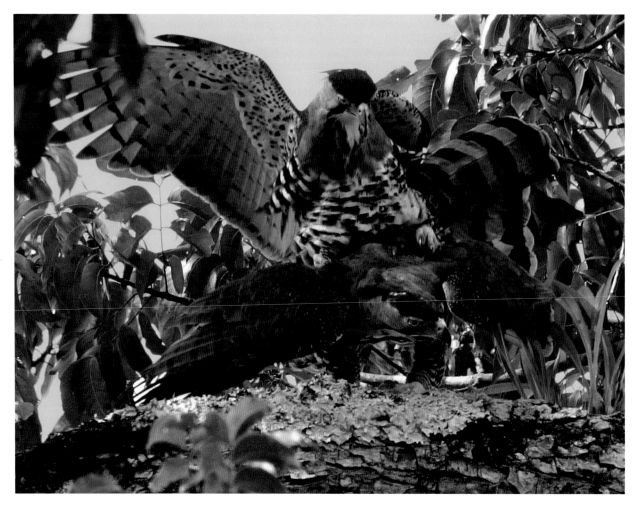

Ornate Hawk-Eagles, shown here at the beginning of the reproduction cycle, are among the largest birds of prey in the forest and need a large habitat to thrive. Hawk-Eagles are typically monogamous and return to the same tree every two years to build a nest and raise their young.

For example, as John Kricher explains in his indispensable *A Neotropical Companion,* orchids usually rely on fungi to help take in water and minerals, and the fungi survive by ingesting some of the carbohydrate by-products that result from the orchid's photo-synthesis. What's more, the orchids need bees and other insects in order to cross-pollinate, and bromeliads trap moisture for all sorts of creatures living in the canopy, including frogs, mosquitoes, and salamanders.

Meanwhile, if you take time to observe those amazing leaf-cutter ants, you'll see an incredibly complex civilization underfoot, with ants moving briskly in two directions in well-delineated lanes. They harvest leaves from trees as far as fifty yards away and bring them to huge underground colonies.

At first glance, the ants couldn't look simpler. Ants headed in one direction are carrying little pieces of leaf, while ants headed in the opposite direction are unencumbered. Look closer and you'll notice other ants, riding atop the leaves. These smaller ants

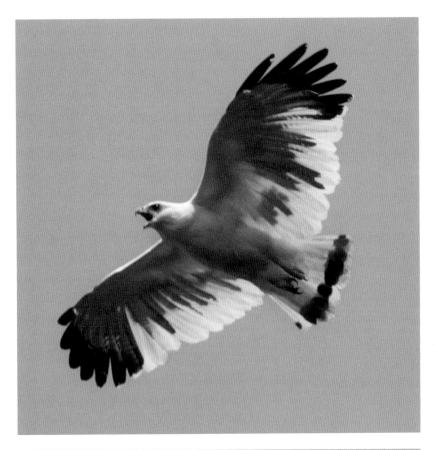

The White Hawk ranges from southern Mexico through Nicaragua. Though typically seen flying above the canopy, it also flies inside the canopy or along the forest's edge in search of rodents and reptiles.

The Bat Falcon ranges from the Yucatan through South America. It perches high in trees and goes after small birds and—of course—bats.

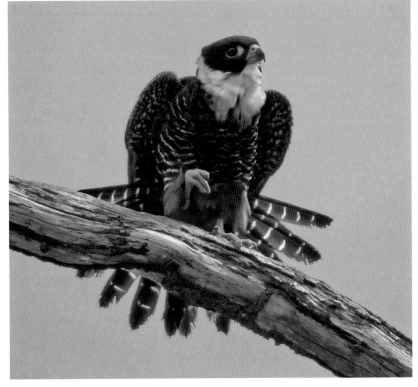

Leaf-cutter Ants begin work at dawn, bringing their cuttings back to a huge underground colony of more than a thousand chambers that may be home to as many as a million ants. They mark their trails by excreting chemicals that their coworkers can smell.

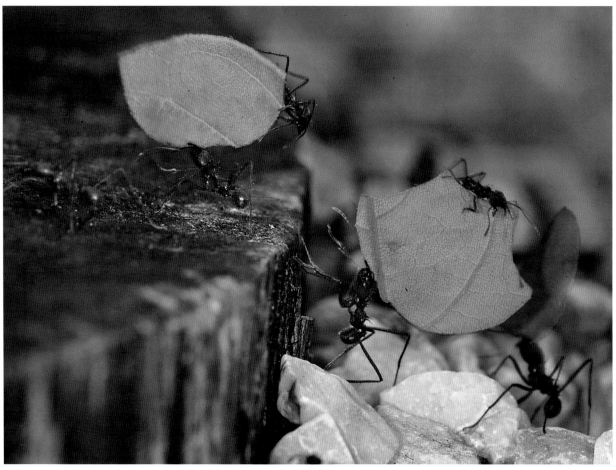

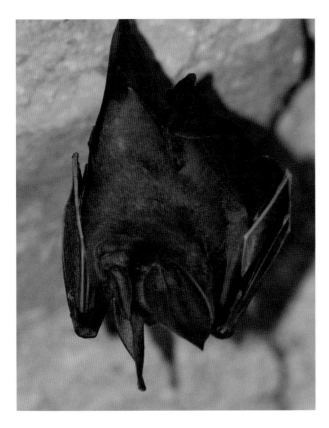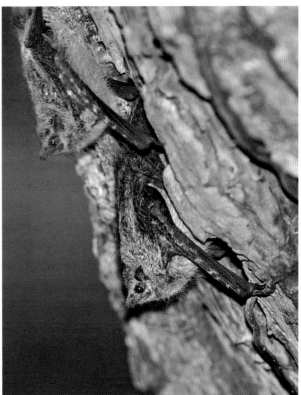

Bats help maintain the forest by dispersing seeds over great distances and by eating insects. In the absence of natural caves, this Leaf-nosed Bat (left) roosts in a looter's trench found in Maya ruins. The Long-nosed Bat (right) roosts camouflaged on the side of a tree.

are cleaning the leaves on the way to the colony, to rid them of contaminants.

Once they arrive in the colony, the ants tend a huge fungus farm, fueled by chewed leaves and the ants' enzyme-rich saliva. It's not just any fungus, mind you, but a very specific type found only in the ant colonies. When the fungus ripens, the ants eat it and feed it to their larvae. In the process, they help break down the leaves into nutrients needed for plants and trees to grow in the shallow tropical forest soil.

Other important and vastly underrated denizens of the tropical forest are bats. While many birds disperse seeds through their feces, their range is limited. Little short-tailed fruit bats, in contrast, can disperse upwards of forty thousand seeds a night over huge swaths of open land in one night. Trees and shrubs germinate from the seeds, the birds arrive, and the forest is naturally regenerated. Insectivorous bats, meanwhile, feed on weevils, moths, and other bugs that damage leaves and devour the seeds. Says Wildlife Conservation Society researcher Dr. Bruce Miller, who has studied bats in Belize for more than a decade, "The ecological services that bats provide are what's really going to be critical for long-term preservation of the ecosystem. If we lose the bats, we lose the forest."

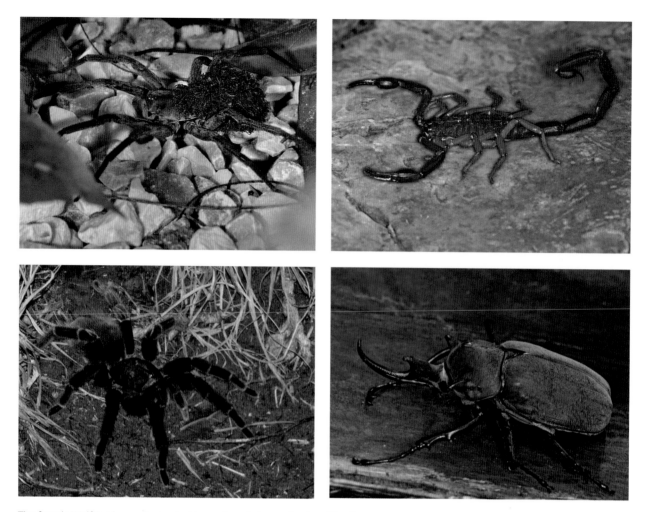

The female Wolf Spider carries her babies on her abdomen (top). A Tarantula leaves its burrow (bottom). Both of these spiders are nocturnal.

The Scorpion (top) is known for its pincers and venomous tail, which may sting, but it is not lethal. The Rhinoceros Beetle (bottom) is notable for its prominent horn. It lives in large dead trees.

At the other end of the food chain are the raptors and big cats. Ultimately, everything is connected in a mammoth jigsaw puzzle of biodiversity and symbiosis. Too often in the industrialized world, nature exists in a world largely defined by humans. In the jungle of the Maya, humans live in a world defined largely by nature.

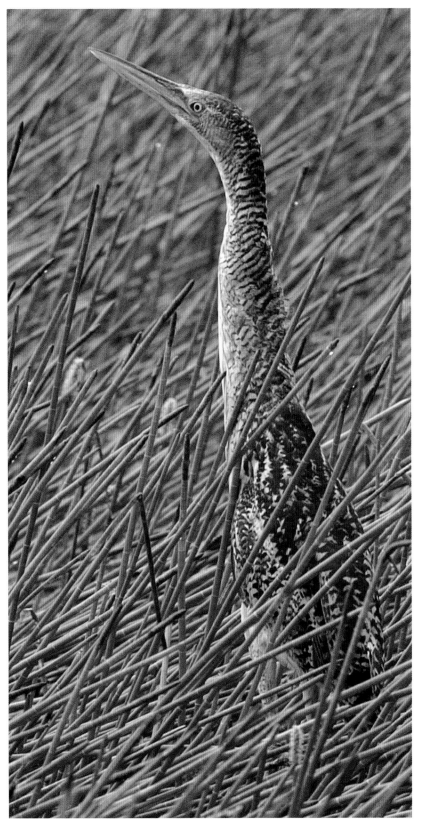

An ordinarily bashful Pinnated Bittern stands in tall grass. This bird lives in lowland wetlands and eats mostly fish, amphibians, crustaceans, and sometimes insects.

This Boa Constrictor is looking especially spiffy because it has just shed its old skin.

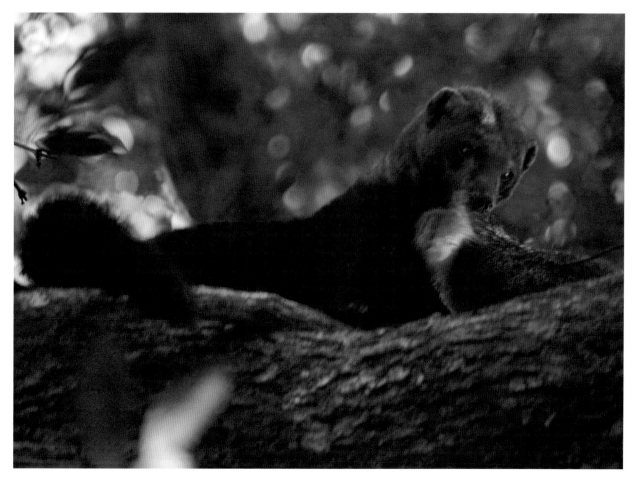

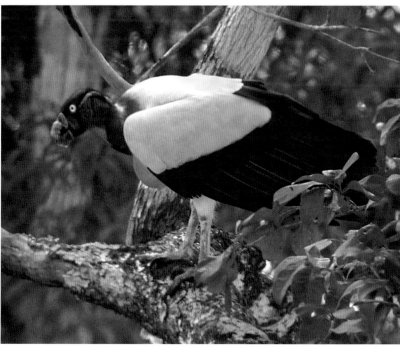

A Tayra, a type of weasel, polishes off an Agouti.

As buzzards go, the King Vulture is one of the more handsome specimens.

*T*o be fully appreciated,
the subtle beauty of a
rain forest must be seen
up close and in detail.

ADRIAN FORSYTH
AND KEN MIYATA,
TROPICAL NATURE

Howler Monkeys are endangered because
they need plenty of uninterrupted habitat,
and the Selva Maya has become increasingly
fragmented.

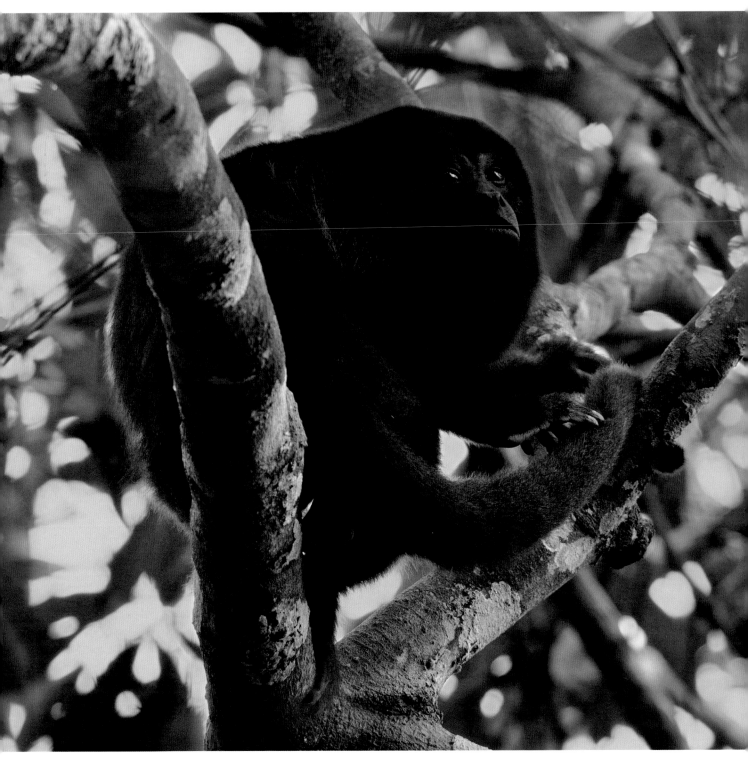

The Future of the Forest

To the typical visitor, the vast Selva Maya region is a rugged paradise, as removed from the pressures of the modern world as a person could get. There are troubling reports of encroachment: parcels of forest being cleared by indigent farmers, a new dam in Belize, the persistent talk about a highway connecting Cancun to Tikal, possible electrical and natural-gas transmission lines in Guatemala's Peten. Nevertheless, the natural reaction is not to worry. After all, in a forest as vast as the Selva Maya, how much damage can human progress cause?

Unfortunately, such intrusions, taken together and over the long haul, are causing irreparable harm. By one estimate, roughly 200,000 acres a year are lost to deforestation. The jungle of the Maya faces a slow but inevitable demise—literally, a death by a thousand cuts—unless humans back off.

Here's why. Humans and the forest are too often on a collision course as a result of entrenched poverty, increasing population, and development pressures. Slash-and-burn farming (just as horrible as the name implies) is a main culprit. The fires provide nutrients for the thin layer of topsoil, but the soil is soon depleted and more forest must be razed. New highways contribute to the problem because they fragment the forest, thereby opening inaccessible parts of the Selva Maya to farming and other development.

Writing about the destruction of the forest is difficult because, while it continues, it is in a state of flux. Guatemala has long been of primary concern. Until a new regime took over in late 2003,

Biodiversity is not evenly distributed on Earth. It is found in greatest concentrations in tropical forests, which comprise just 7 percent of the planet's dry land surface but hold more than 50 percent of all species.

DIANE JUKOFSKY,
*ENCYCLOPEDIA OF
RAINFORESTS* (2002)

much of the country was lawless. In the Peten region, the biosphere reserve has been a demilitarized zone, with drug trafficking and the looting of Maya ruins commonplace, wildlife poaching rampant, and huge chunks of jungle razed and burned for cattle grazing or subsistence farming. The nadir occurred earlier that year, when NASA satellite images showed much of the Peten ablaze.

Human invaders have also set fire to nesting sites of the endangered scarlet macaw and other wildlife habitat so that the land no longer has conservation value. By one count, only 300 scarlet macaws still remain in Guatemala's Maya Biosphere Reserve.

The problems in Mexico may not be as dire, but the Selva Maya there still faces enormous pressures. A largely poor and landless population keeps intruding into biosphere reserves, killing wildlife for food, removing hardwood trees, and, increasingly, appropriating parts of forest for subsistence agriculture.

Meanwhile, in Belize, which has long been considered a leader in conservation, the situation is in flux. In 2004, the government instituted a new property tax, and there is pressure on landowners in the tropical forest to sell land to pay the tax. The other problem in Belize has been poaching of both mahogany and wildlife. The border with Guatemala is unprotected, and poachers from the west see tempting targets. Looting is not as big a problem, in part because sites were looted decades ago.

The situation for the Selva Maya could get worse if an ecotourism road from Cancun to Tikal gets built. The road would fragment the forest. It would give poachers easier access to natural treasures,

An example of slash-and-burn agriculture, using an old tire to fuel the fire. A living forest absorbs carbon dioxide, but every time the forest is cleared and burned, it releases huge amounts of carbon dioxide.

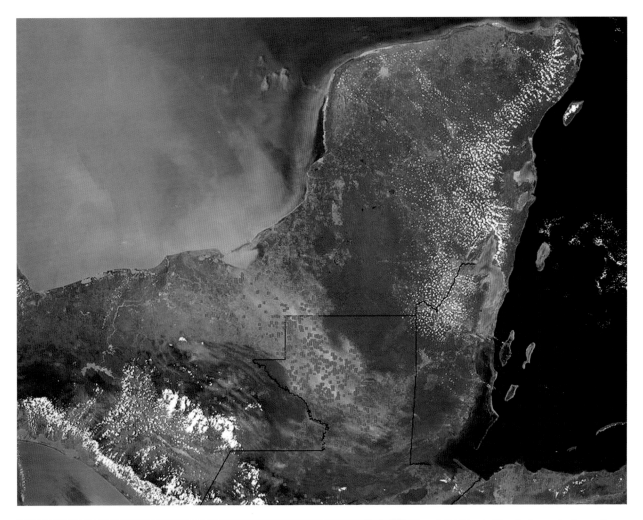

A NASA satellite photograph shows the extent of fires in the Selva Maya in the spring of 2003, when roughly a million acres of forest were lost. The red dots represent fires, and the gray is smoke drifting north over the Gulf of Mexico.

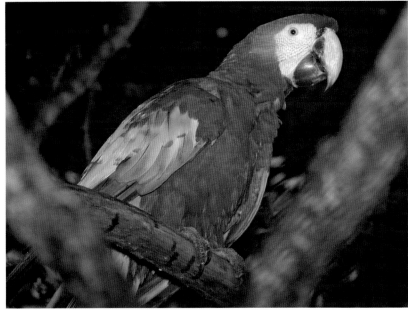

Scarlet Macaws, increasingly endangered, have lost nesting sites at an alarming rate because supposedly protected areas are being deforested illegally.

and it would open vast portions of the jungle to land-starved squatters, setting off a whole new cycle of slash-and-burn farming.

Returning to the question raised at the start of this chapter: What's so bad if the jungle keeps shrinking? After all, as long as there's jungle, even at half the size, the wonderful mosaic of flora and fauna will continue to thrive, right?

Wrong. That's not how tropical forests sustain themselves. Consider Barro Colorado Island in Panama. It was once a hilly portion of a tropical forest, but when the Panama Canal was built, the Chagres River was dammed, the surrounding forest became submerged, and the land became a six-square-mile island. In 1923, it became a nature reserve and has been studied ever since.

Six square miles may seem like a lot of land, but large predators such as the jaguar, the puma, and the harpy eagle were soon lost. That touched off a ripple effect. Their prey (agoutis, opossums, coatis, and peccaries) proliferated and devoured not only the seeds of trees and other vegetation but also the eggs and the young of many bird species that nest near the ground. The composition of the jungle has been altered, including the loss of two dozen species of birds.

In short, the island just isn't large enough to sustain adequate biodiversity. In similar situations in Venezuela and Thailand, similar results occurred. The main concern is that if the jungle of the Maya continues to be fragmented, the fragile balance of nature there will be thrown irrevocably off-kilter.

The health of the Selva Maya depends on keeping it largely intact, and the health of the Western Hemisphere depends on the health of the Selva Maya. Beyond all of its other contributions, the

For decades, tropical forests were ripped up for their prized mahogany. Opposite page, bottom, a scene from Gallon Jug in Belize (then British Honduras) in the 1940s, when mahogany harvesting was uncontrolled. Today, long after the area was declared off-limits to mahogany poachers, the jungle is reclaiming the old tree-cutting machinery (opposite page, top).

The forest must be saved for the generations that follow, including our friends shown here, from the Gallon Jug Community School.

Sustainable nontimber forest products include shade-grown coffee (above) and chicle, which is used for natural chewing gum. The chicle comes from the Sapodilla tree (right). Chicleros use machetes to cut the tree trunk. The latex oozes out and drips into a wax-lined cloth bag, which is later collected.

forest serves as a global climate control, combating global warming by absorbing carbon dioxide through photosynthesis. Conversely, when the jungle is burned, it emits huge amounts of carbon dioxide, a key component in the greenhouse effect. What happens in the forests of Belize, Guatemala, and the Yucatan has more of an impact on the United States' own domestic conservation efforts than what takes place in more-distant tropical locales.

The strategy to save the Selva Maya ranges from the basic to the high-tech, and the central idea is to protect as much of the forest and its biodiversity as possible. For example, unless all roads into the Maya forest have ranger posts to control access, they will become pathways to destruction.

International conservation organizations have worked with the governments of Central America to develop biological corridors that connect the large protected areas, enabling large cats and other mammals to travel back and forth. A key element in protecting such species as the jaguar is to maintain a population base large enough to have the genetic interchange needed for survival.

Conservation groups also work with the governments and local groups to preach sustainable development, such as encouraging forest-friendly ecotourism and legal logging activities, or teaching farm-

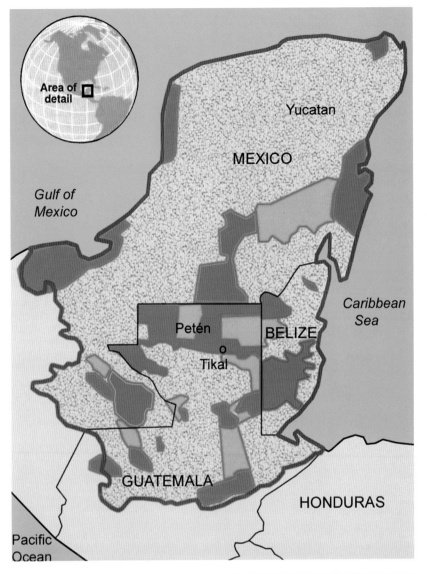

The three nations of Guatemala, Mexico, and Belize have created biosphere reserves, national parks, and other conservation areas (green) to protect the jungle, conduct scientific research, and seek sustainable development. Additionally, several corridor areas (pink) offer some protection. (The ancient Selva Maya is outlined in red.)

Guatemala has 5 million acres within the Maya Biosphere Reserve.

Mexico's most significant holdings are the 1.5 million acres of the Montes Azules Biosphere Reserve, 1.7 million acres in the Calakmul Reserve, and 1.3 million acres in the Sian Ka'an Reserve.

Belize's Selva Maya holdings include the Programme for Belize's 260,000-acre preserve in the north Rio Bravo area, the 265,000-acre Chiquibul National Park, and the 47,000-acre Chiquibul Forest Reserve farther south.

Victor Emanuel and Barry Lyon lead a birding excursion, one of the many ecotourism activities in the Selva Maya.

Bats and cats are vital to the long-term health of the forest, and both have been studied extensively by Wildlife Conservation Society researchers Bruce and Carolyn Miller in Gallon Jug. Bruce holds an Argentine Brown Bat (right); Carolyn photographed the Jaguar with a camera "trap" (below).

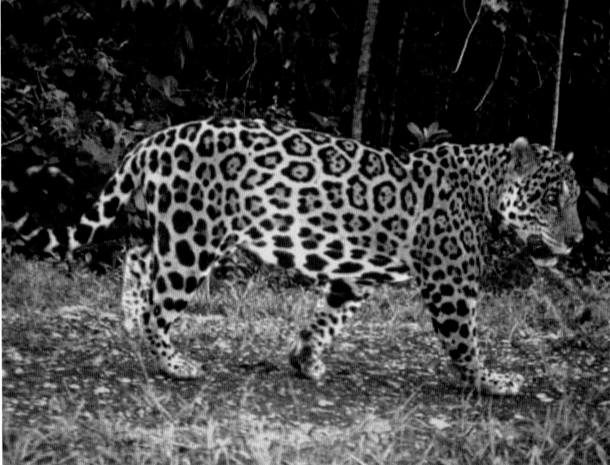

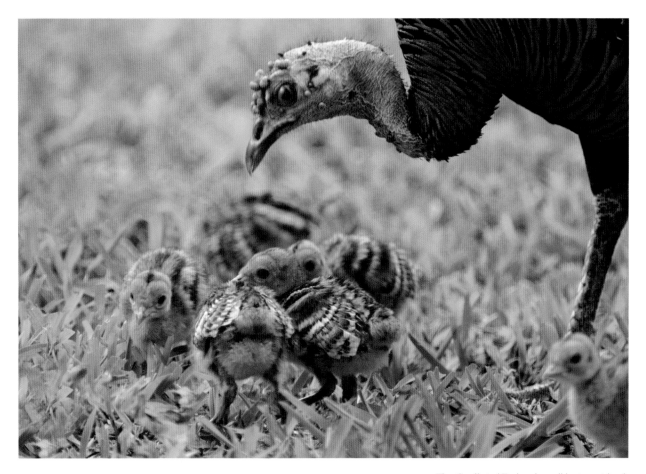

The Ocellated Turkey has all but vanished, save for well-protected areas. When the Spaniards arrived some 500 years ago, wildlife was so abundant that inhabitants called the region "the land of deer and turkey."

ers to grow crops, such as shade-grown coffee, that don't destroy the tropical forest. Another strategy is to offer financial incentives to landowners to keep their property forested and to illegal biosphere settlers to repair the environmental damage they have done and move to a more suitable location.

Among the high-tech protections for the forest is the use of NASA satellite imagery to help determine the cause, location, and extent of the fires in the Selva Maya. The next step is to acquire tanker airplanes to drop fire suppressants on the blazes. These planes have been used to fight forest fires in the United States for decades.

You can help save the Selva Maya. You can support the conservation organizations that protect the jungle and the creatures therein; several prominent conservation groups are listed in the acknowledgments of this book. Through responsible ecotourism, you can support the local economies within the Selva Maya. You can urge industrialized countries to forgive loans to the nations of the Selva Maya in exchange for protecting more of this irreplaceable forest.

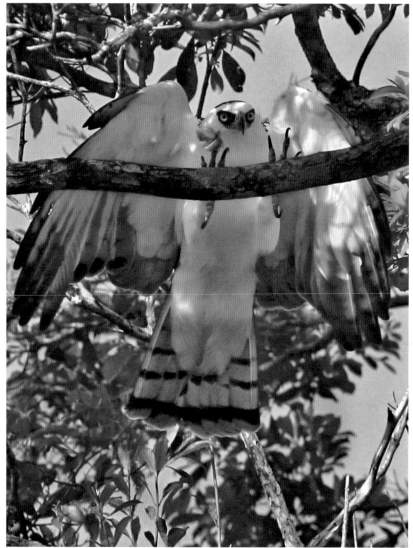

A Black-and-white Hawk-Eagle, most frequently seen soaring above the canopy, comes in for a landing (right). An immature Harpy Eagle (above), to be released into the wild, is one of the rarest, most endangered raptors of the jungle. Both need large swaths of forest to survive.

Wildlife Conservation Society researcher Carolyn Miller likes to refer to the highly protected 133,000-acre Gallon Jug property of northwestern Belize as a "wildlife factory" that churns out the prey that a healthy jaguar population needs to thrive. In fact, the entire Selva Maya is a wildlife factory and sanctuary serving the entire Western Hemisphere.

The jungle of the Maya is one of nature's truly incredible places, and it is crucial to this planet's future. This vast forest must be both revered and protected, not only for its sake, but also for our own.

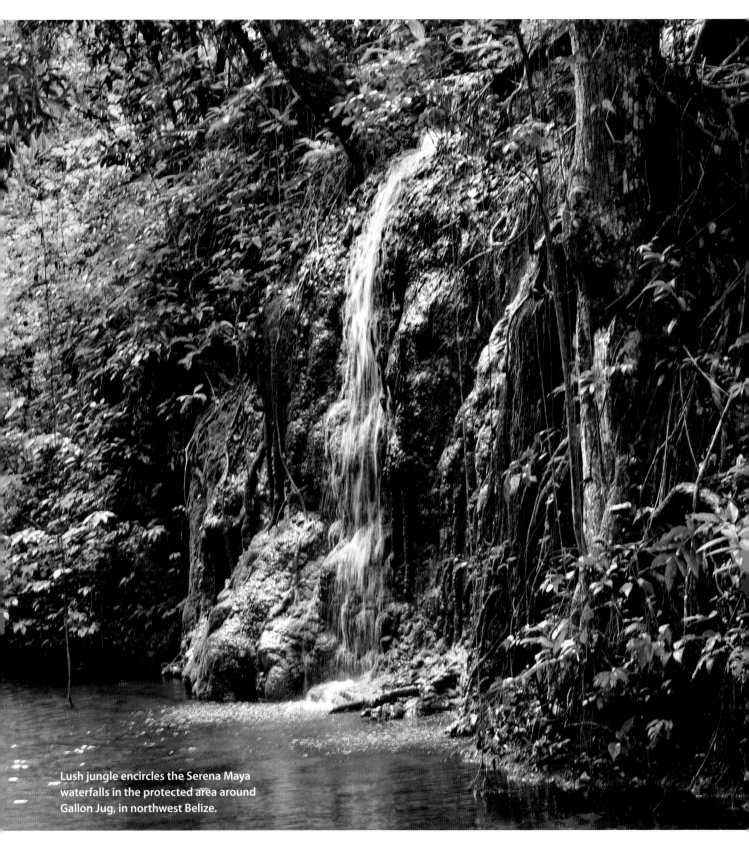

Lush jungle encircles the Serena Maya
waterfalls in the protected area around
Gallon Jug, in northwest Belize.

Laguna Seca, a lake in the same region, is seen at sunset.

Further Reading

TROPICAL FORESTS AND CREATURES

Alterton, David, *Wild Cats of the World,* Facts on File Books, 1993.

Arnett, Ross H. Jr., and Richard L. Jacques Jr., *Guide to Insects,* Simon & Schuster, 1981.

Arvigo, Rosita, *Rainforest Medicine Trail Field Guide,* Ix Chel Tropical Research Foundation, 1992.

Brock, Jim P., and Kenn Kaufman, *Butterflies of North America,* Houghton Mifflin, 2003.

Carter, David, *Butterflies and Moths,* Dorling Kindersley, 1992.

Emmas, K. M., et al., *Cockscomb Basin Wildlife Sanctuary,* Producciones de la Hamaca and Orang Utan Press, 1996.

Forsyth, Adrian, and Ken Miyata, *Tropical Nature,* Charles Scribner's Sons, 1984.

Green, Harry W., Michael Fogden, and Patricia Fogden, *Snakes,* University of California Press, 1997.

Head, Suzanne, and Robert Heinzman, eds., *Lessons of the Rainforest,* Sierra Club Books, 1990.

Henderson, Carol L., *Field Guide to the Wildlife of Costa Rica,* University of Texas Press, 2002.

Horwich, Robert H., and Jonathan Lyon, *A Belizean Rain Forest,* Orang-utan Press, 1998.

Howell, Steve N. G., and Sophie Webb, *A Guide to the Birds of Mexico and Northern Central America,* Oxford University Press, 1995.

Janson, Thor, *Maya Nature,* Vista Publications, 2001.

Jones, H. Lee, *Birds of Belize,* University of Texas Press, 2003.

Jukofsky, Diane, *Encyclopedia of Rainforests,* Oryx Press, 2002.

Klots, Alexander B., *A Field Guide to the Butterflies,* Houghton Mifflin, 1951.

Kricher, John, *A Neotropical Companion,* Princeton University Press, 1997.

Red-eyed Vireo

Lee, Julian G., *A Field Guide to the Amphibians and Reptiles of the Maya World*, Cornell University Press, 2000.

Lockwood, C. C., *The Yucatan Peninsula*, Louisiana State University Press, 1989.

Miller, Carolyn M., and Bruce W. Miller, *Exploring the Tropical Forest at Chan Chich Lodge*, Wildlife Conservation Society, 1994.

Milne, Lorus, and Margery Milne, *Field Guide to Insects and Spiders*, National Audubon Society, Alfred A. Knopf, 1980.

Myers, Norman, *The Primary Source*, W. W. Norton, 1984.

National Audubon Society, *Field Guide to Butterflies*, Alfred A. Knopf, 1981.

Oldfield, Sara, *Rainforest*, MIT Press, 2002.

Opler, Paul A., and Vichai Malikul, *Eastern Butterflies*, Houghton Mifflin, 1992.

O'Toole, Christopher, *Insects and Spiders*, Firefly Books, 2002.

Peterson, Roger Tory, and Edward L. Chalif, *Mexican Birds*, Houghton Mifflin, 1973.

Pianka, Eric R., and Laurie J. Vitt, *Lizards*, University of California Press, 2003.

Primach, Richard B., et al., eds., *Timber, Tourists, and Temples*, Island Press, 1998.

Quinlan, Susan, *The Case of the Monkeys That Fell from the Trees*, Boyds Mills Press, 2003.

Rabinowitz, Alan, *Jaguar*, Arbor House, 1986.

Sbordoni, Valerio, and Saverio Forestiero, *Butterflies of the World*, Firefly Books, 1998.

Schlesinger, Victoria, *Animals and Plants of the Ancient Maya*, University of Texas Press, 2001.

Skutch, Alexander F., *Trogons, Laughing Falcons, and Other Neotropical Birds*, Texas A&M University Press, 1999.

Stafford, Peter J., *A Guide to the Reptiles of Belize*, Academic Press, 1999.

Ziegler, Christian, and Egbert Giles Leigh Jr., *A Magic Web*, Oxford University Press, 2002.

THE ANCIENT MAYA

Baudez, Claude, and Sydney Picasso, *Lost Cities of the Maya*, Harry N. Abrams, 1992.

Bustos, Gerardo, *Yucatan and Its Archaeological Sites*, Monclem Edicions, undated.

Coe, Michael, *Breaking the Maya Code*, Thames & Hudson, 1993.

Coe, Michael, *The Maya*, Thames & Hudson, 1992.

Coe, William R., *Tikal: A Handbook of the Ancient Maya Ruins*, University of Pennsylvania Press, 1988.

Houk, Brett A., *The Ruins of Chan Chich*, Chan Chich Archaeological Project, 2001.

Ivanoff, Pierre, *Maya*, Grosset & Dunlap, 1973.

Laughton, Timothy, *The Maya: Life, Myth, and Art*, Barnes & Noble Books, 2004.

Mann, Elizabeth, *Tikal*, Mikaya Press, 2002.

Schele, Linda, and David Freidel, *A Forest of Kings,* William Morrow, 1990.

Sharer, Robert J., *The Ancient Maya,* Stanford University Press, sixth ed., 2005.

Stephens, John L., *Incidents of Travel in Yucatan,* Smithsonian Institution Press, 1996.

Stuart, George E., and Gene S. Stuart, *The Mysterious Maya,* National Geographic Society, 1977.

INTERNET SITES

Web sites with extensive information and good links:
www.biologicaldiversity.info
www.biomeso.net
www.nhm.ac.uk/botany/lascuevas/index.html
fwie.fw.vt.edu/wcs/index.htm
www.peregrinefund.org
www.savethejaguar.com
www.naba.org
www.wildherps.com/references.html

A Ceiba tree, the national tree of Guatemala, reaches skyward in an open area at Tikal. The branches are covered with epiphytes.

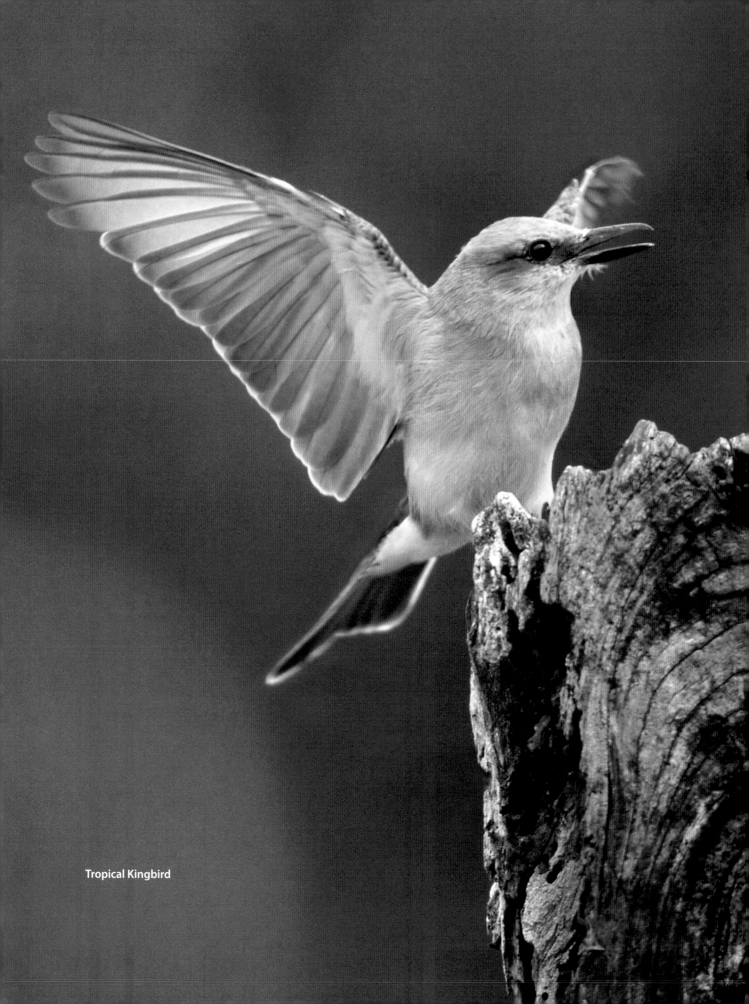
Tropical Kingbird

Acknowledgments

o many people helped us with this enormous project that we can't thank them all. But we can begin by thanking Nick and Brigitte Bougas, the managers of Chan Chich Lodge in northwestern Belize from 2001 to 2004, without whom this book never would have gotten off the ground.

Wildlife Conservation Society stalwarts Bruce and Carolyn Miller, who love the Selva Maya dearly and who have done everything they possibly could for this project, have been incredibly helpful as well.

Barry Bowen, the owner of the lodge, has been most supportive. Others who were a huge help at Chan Chich and Gallon Jug, where many of the photographs were taken, include Norman Evanko, Zander Bowen, Luis Romero, Rubén Blanco, Raúl Martínez, the other guides, and the rest of the staff.

At Tikal National Park, Tony Ortiz of the Hotel Jungle Lodge was a huge help and resource.

We'd also like to thank a raft of experts for their expertise and patience: Jan Meerman of the Green Hills Butterfly Ranch in Belize, Roan McNab of the Wildlife Conservation Society in Peten, Dr. Hugh Robichaux of University of the Incarnate Word, Dr. Fred Valdez of the University of Texas at Austin, Dr. Peter Schmidt of the Archaeological Project of Chichen Itza, Marcelo Windsor of the Belize Forest Department, Humberto Wohlers of the Belize Zoo, Victor Emanuel of Victor Emanuel Nature Tours, Dorcas MacClintock, Dr. Scott Silver and Linde Ostro of the WCS in Cockscomb Basin, Dave Whitacre of the Peregrine Fund, and Ignacio March of Conservation International in Mexico.

We wish to thank all of the helpful guides at other Maya sites in Lamanai, La Milpa, and Yucatan, plus the guides at Cockscomb Basin, the Community Baboon Sanctuary, and Chaa Creek, including the Rainforest Medicine Trail at Ix Chel Farm, in Belize. We also thank two pilots for their information, their enthusiasm, and especially their assistance with

Heliconia seed pods

127

our aerial photography: Daniel Perdomo of Javier's Flying Service in Belize and Aníbal Sandoval Herrara of Flores, Guatemala.

We'd like to acknowledge the assistance and encouragement we have received from so many other people we have encountered over the course of this project, including fellow visitors to the region.

We thank Dianne DiBlasi for her editing advice and Deedee Burnside for her valuable input.

Finally, the authors wish to thank Stiles Thomas, who introduced us to the jungle of the Maya and provided invaluable guidance over the course of this project.

We are indebted to our wives, Debbie, Patty, and Adrienne, for their help and support, and for their patience whenever we became overly obsessed with the book and the Selva Maya.

As noted in the introduction, most photographs in this book were taken in the wild, with a few exceptions. The photographs of the cats (except for the ocelot), the scarlet macaw on page 111, and the young harpy eagle on page 118 were shot at the Belize Zoo. Butterflies on pages 32 and 34 (bottom) were photographed at the butterfly farm at Cockscomb Basin.

The photograph of the open-winged morpho butterfly on page 91 is by Carolyn Miller, as is the jaguar trap shot on page 116. The historical photo of Chichen Itza on page 84 is courtesy of the Abbot-Charnay Collection, American Philosophical Society. Jim Wright took the photographs of the Maya sites in the Yucatan. The map of the protected conservation areas and corridors on page 115 is based on maps presented by Mesoamerican Biological Corridor Project. The satellite image of fires in Central America on page 111 is from NASA, used with permission. The historical photograph of logging on page 112 is courtesy of the Gallon Jug General Store.

In conclusion, we would like to credit the many conservation groups that provide protection, research, and education related to the Selva Maya and other threatened areas of the world. These include but are not limited

Photographers Doug Goodell and Jerry Barrack (below left) use Canon equipment. Early in this project, EOS-1v cameras were used with Fuji Provia-F film. For most of the project, digital cameras were used, including the EOS-1Ds and 10D. Lenses range from 24 mm wide-angle to 600 mm telephoto (often with multipliers). On occasion, local species get very involved in the photographers' work (above).

Writer Jim Wright (below right) uses Bic and Papermate blue medium-point pens, Allied legal pads, and a laptop computer. Here, Jean the Guan shows Jim the art of hunt-and-peck penmanship.

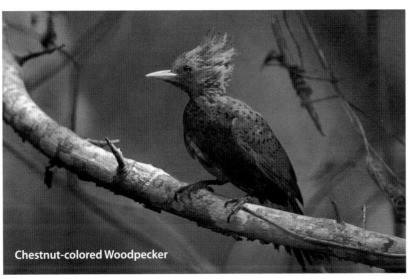

Chestnut-colored Woodpecker

Nick and Brigitte Bougas (above left) were managers of Chan Chich during much of this project. Both are resource treasures and provided the authors with much assistance.

Bruce and Carolyn Miller (above center) are Wildlife Conservation Society researchers who work at Gallon Jug. Their work and knowledge covers areas throughout Central America.

Tony Ortiz (above right) of Hotel Jungle Lodge in Tikal National Park is also a guide. His personal knowledge of the area goes back to his father's work with archaeological excavations there.

to The Wildlife Conservation Society (www.wcs.org), Programme for Belize (www.pfbelize.org), The Nature Conservancy (www.nature.org), The World Land Trust (www.worldlandtrust.org), Conservation International (www.conservation.org), The Peregrine Fund (www.peregrinefund.org), and The World Wildlife Fund (www.wwf.org).

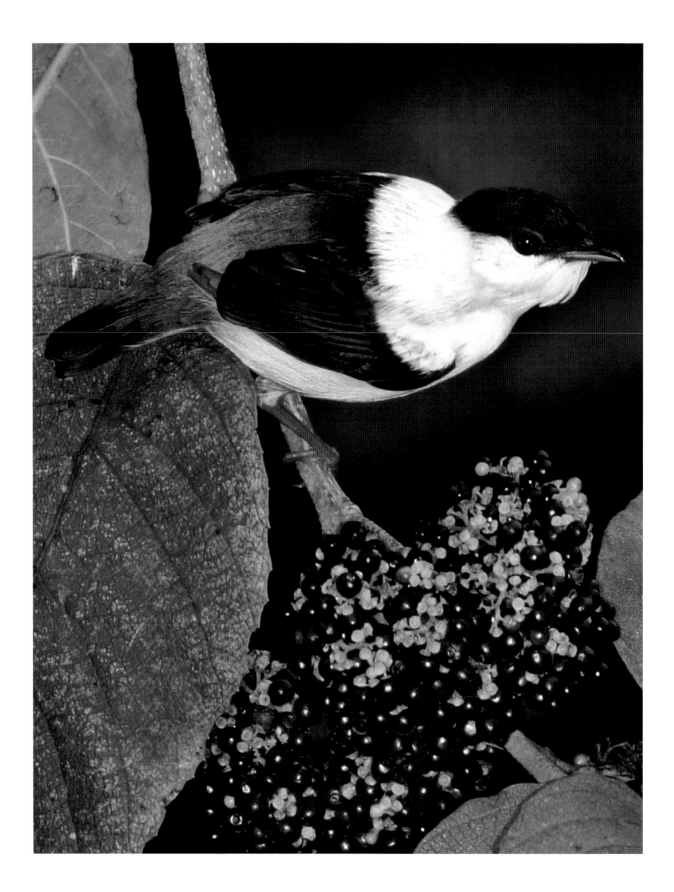

Index